Roller

Roller

A Chameleon Book

THE PAINTINGS OF DONALD ROLLER WILSON

Introduction by Peter Frank

Chronicle Books
San Francisco

Produced by
CHAMELEON BOOKS, INC.
211 West 20th Street
New York, New York 10011

Production director/designer: Arnold Skolnick
Editorial director: Marion Wheeler
Associate editor: Stephen Frankel
Editorial assistant: Ellen Dibble
Design assistant: Kathleen Unruh
Composition: Ultracomp, New York, New York
Production services: Four Colour Imports, Ltd., Louisville, Kentucky
Principal photography: Rick Green, Johnson, Arkansas
Additional photography: Toby Old, New York, New York; Rich Gardner,
 Houston, Texas; Mike Fizer, Wichita, Kansas; and
 Douglas M. Parker Studio, Los Angeles, California

This book was produced in connection with the exhibition,
"Roller: The Paintings of Donald Roller Wilson," organized and
toured by Mid-America Arts Alliance, Kansas City, Missouri,
whose partners include the state arts agencies of Arkansas,
Kansas, Missouri, Nebraska, Oklahoma, and Texas, the National
Endowment for the Arts, and private sector contributors.

Printed and bound in Hong Kong
Library of Congress Cataloging-in-Publication Data Available

Distributed in Canada by
Raincoast Books
112 Third Avenue
Vancouver, B.C. V5T 1CB

10 9 8 7 6 5 4 3 2 1

CHRONICLE BOOKS
San Francisco, California

front cover: PATRICIA'S LATE-NIGHT COMPLEMENTARY
 SNACK AT MONTE'S, detail
back flap: KATHLEEN
back cover: CAME FROM WISHING, ON THE FRONT PORCH

CONTENTS

ARTIST'S ACKNOWLEDGMENTS

I DEDICATE THESE IMAGES, WHETHER THEY LIKE IT OR NOT, TO
GARY, PAUL, AND JOHN, WHO APPARENTLY BELIEVE IN ME…THEY ARE
PROBABLY FROM OUTER SPACE BUT DON'T LIKE TO SHOW IT, SO THEY
JUST HANG AROUND IN THE BANK AND MAKE IT SO I CAN PAY MY RENT.
GARY AND PAUL ARE FARM DOGS. JOHN IS A TOWN DOG. THEN, THERE
ARE THE GUYS BEHIND THE COE KERR LUNCH COUNTER WHO MAKE SURE
I EAT. AND, THEN, THERE ARE J.J. AND GUY, AND I LOVE THEM A LOT.
AND THERE IS MY RABBIT ALONG WITH *THE GIRLS WHO HAVE HELPED
ME*…FREDA, JUDEE (ALONG WITH *MR. MONICALBURGER*), BETTY, HOLLY,
CARRIE, AND ANN AND LEIGH…AND THEY ARE ALL BLONDE FARM DOGS
WITH THE EXCEPTION OF BETTY WHO, THOUGH SHE IS ALSO A FARM DOG,
IS BROWN…AND *MAD*.

AND, THEN, THERE IS THAT STRONG WIND WHICH WHIPS UP EVERYNIGHT…
AND MRS. JENKINS AND EVERYONE IN HER HISTORY (TO DATE). I AM
THANKFUL OF THAT LINE-UP! AND THERE ARE THE SHIPS AT SEA…
AND THE FLOWERS OF THE FIELD.

SO, AS YOU EXAMINE THESE SMALL SMOKING AND NON-SMOKING LITTLE
FOLKS, WHICH I DEAL WITH MOST EVERY DAY, AND THE FLYING CHUNKS
OF MELON AND OTHER RELATED AND NON-RELATED BITS AND PIECES OF
MATTER WHICH LIFT UP OFF THE FLOOR (?) OF MRS. JENKINS' SMALL
HOUSE IN THE FIELD, KNOW THAT WHAT YOU SEE IS NOT WHAT YOU GET.
DO YOU UNDERSTAND? IF YOU DO…YOU DO. IF YOU DON'T…YOU NEVER
WILL. BUT JUST GIVE ME TEN MORE YEARS AND I WILL PAINT YOU
A PICTURE OF PARADISE.

LIST OF PAINTINGS

A WORD FROM THE ARTIST

So, here I am in Fayetteville, Arkansas, and nobody really knows what I am doing here, even though it is all right in front of their eyes.

As I see it, New York City is like a big, beautiful, elaborately carved—and lighted—ice sculpture surrounded by little stuffed, juicy, layered things and soft, wiggling things and pâtés and frappés and soufflés and little pies and tortes and snorts. But, even though Fayetteville has its snorts, too, when you get right down to it, Fayetteville is really more like a cake mix, and the state of Arkansas is the box for it. And, if Fayetteville were a Lady Baltimore cake (which I don't think they make as a mix but let's just suppose that they do), there would be only one raisin in it and that would be me. Probably, in all honesty, one of the reasons living here is good for me is that there aren't any attractions out on the street to draw me out of my studio. If I lived in New York, I would probably get involved in a lot of innuendo that would be basically nonproductive. In Fayetteville, there is no innuendo, so all I have to do here is my work.

When people look at my work, they are fascinated with what they see because, even though the paintings are elegantly painted, the choice of objects in them is kind of cock-eyed. The objects in the paintings are real dumb, tacky, cheap objects—everyday things—but they are arranged in elaborate settings that seem to contradict what they are really all about. The objects that appear in my work—whether they are skeleton bones, table or floor lamps, cardboard boxes, hot dogs, bottles of vinegar or ketchup, chicken legs, fresh fruit or vegetables, bowls, vases, jars, feathers, or other knickknacks—all have the capability of appearing anywhere at any time. For, although the paintings themselves are very still, the objects in them can—and do—move from one painting to another.

People are also fascinated by the fact that the animals in the paintings are dressed up like humans. Some folks think that what I am doing is making

fun of people by making the animals look like them—or vice versa, depending on the point of view. But enough of these conjectures. I do deliberately and repeatedly use certain objects and the same characters from picture to picture. And there is a better—more serious—reason for my doing this than simple satire, but the reason may not be visible to those who cannot see it.

My work has been developing here since 1969 or 1970, when I started working very seriously—even feverishly—in the narrative format. And, since the narrative content of my work is probably, for me, the most important thing about my work, it is safe to say at this point that the ongoing story, which is highly conceptual and unfolds almost like a soap opera, is what concerns me first and foremost.

It takes a long time and lot of thought and a lot of work and a lot of maturity (I use that word even though I hate it) to find out who it is you are or who it is you might be or who it is you might have the potential to be; and I know firmly in my heart and in my soul that right now the story is the most important thing for me. When I react to that story, which is constantly evolving in my mind, by painting what are basically illustrations for it, it is the story that excites me not the actual production of the illustrations, which is pretty much just automatic hard work, conditioned by discipline and practice at the highest level I can muster. It's of secondary importance to me that I paint pictures. It's almost a chore to paint them. But the reward I get from performing that chore is the joy of thinking about the intricate ways in which the characters play their parts, become one and then the other, interact with one another, interact with inanimate objects, and are guided by the spiritual force that emanates from the central character, who is now Mrs. Jenkins, who was before now, Mrs. White, who is also Aunt White. Which brings me to the story and the characters.

The story begins with Mrs. White in New York City: One hundred, eighteen years ago, the chunk of Manhattan schist beneath 405 Lexington Avenue came within sixty-five feet of topsoil, grass, and fenced-in pasture. Peter Cooper, known to New Yorkers of his day as the first citizen of New York, was the owner of the property. A woman named Mrs. White lived in the little white farmhouse that stood on Cooper turf.*

Mrs. White is an ape, and she dates back to 1972 and the beginning of my story. She probably first appeared—unnamed and undressed—in 1969 in a painting entitled MERCY LANDS CRIED JACK! WHAT'S COMING OFF HERE? (in the guise of a white ape named Snowflake, whose photograph was on the cover of *National Geographic* in 1967 or 1968). But later on she became Mrs. White/Aunt White as the story began to take shape with the business about the little farmhouse in New York City.

Aunt White is Mrs. White and Mrs. White *is* Aunt White. These two characters are totally interchangeable.** Mrs. White has a distinctly religious bent; she is very spiritual. All the situations she is involved in are rather pure and elevated. She is never seen anywhere near anything at all that even faintly suggests sexual perversity. She is never seen partaking in anything even remotely sinful—she would *never* be seen smoking a cigarette in public—or in private—for example. On the other hand, Aunt White seems to smoke like

*This is written at the top of a drawing I made of Mrs. Jenkins' house.

**Interchangeability among the characters occurs repeatedly because of the way I deal with them. Not only does one character become another closely related character, but the sex of a character is also interchangeable. For example, a boy chimp in one picture might be a girl chimp in another. There are a lot of Siamese-twin situations, too. There are Helen and Helen, fat Arkansas bulldog twins. And there is Betty, a nice chimp, who, at times and quite without warning, can be Naughty Betty. There is a lot of switching back and forth, and I think the ability of the characters to become one kind of character and then another fits in very conveniently with the roles that I assign them, which make them do something naughty at one time, something nice at another. If they have to do something wicked, then something religious, for example, I just shift gears and make the characters work for me as I want them to.

a demon. She probably has jumped into bed with who knows what or whom on numerous occasions and relishes that kind of activity.

Gladys Atlas, who is a human incarnation of Mrs. White/Aunt White, is a central character for a while in the narrative proceedings taking place in the middle 1970s. Even when she is not seen, she is very much present, if only by reference in the titles of the paintings.

Shirley is always a sock doll and she is almost always involved as a voyeur. She serves to observe and report on things that are going on. She is almost like a satellite sent by God to inspect various situations on earth. It is never explained how she appears where she does, but she is always *placed* exactly where she is so she can have a good view of the proceedings. In the early years of the story, Mrs. White/Aunt White was forever sending her out from the farmhouse in New York City to check on things, so she was always all worn out.

Cookie is a baby orangutang, who also lived with Mrs. White/Aunt White in New York. She sometimes dresses as a girl, sometimes as a boy, and she is an animal reincarnation of Shirley. Later in the story, she moves from New York to Arkansas with Mrs. Jenkins.

Mrs. Jenkins is Mrs. White/Aunt White's sister. She is now the central figure of the story and is "in control" of the other characters. She moved to somewhere in Arkansas a long time ago, and she still lives somewhere in Arkansas now (which is an appropriate way to place her because you can hardly find Arkansas even if you are right in the middle of it).

Mrs. Jenkins lives in a little house out on a strange knoll that is surrounded sometimes by cedar trees and sometimes by olives scattered all over the lawn. The house (often called a dog-trot house in Arkansas) consists of two rooms and a long hallway. Mrs. Jenkins moved into her bedroom when she moved into the house and has never been out of it since. She has a Singer sewing machine and an electric fan in there. Mrs. Jenkins smokes a lot. She

is a recovered alcoholic. Outside her bedroom door is the long hallway. It might be 10,000 miles long. It might be light-years long. It might be, in a realistic sense, say, forty feet long. Off this hall is the other room, which serves all purposes. And that's about all there is to the house.

The hallway is *the* place where all the activity in my present work transpires. The walls of the hallway are all scarred by objects that bang against them as a result of the high wind that comes through the hall every night. And the ceiling is so far up that you can't even see it. This is where all Mrs. Jenkins' pals play. This is where they perform the tricks and errands Mrs. Jenkins has them do. She sometimes slides notes through the crack under her bedroom door, instructing various characters to perform certain feats or chores. Sometimes she whispers her comments or directives to one or another character through the keyhole of her bedroom door.

The cast of characters in the hallway (and around the house) includes the following but not in any order of importance.

Patricia is a blond, bushy farm dog, almost always seen with her tongue out. She is not real bright, but, on the other hand, she is pretty bright. She has a few farm-dog friends that might come around the house sometimes, but they are never allowed inside. Patricia is an important character in the line-up of Mrs. Jenkins' friends. She breathes heavily. She has bad vision. She usually wears thick-lensed, green glasses. Sometimes she might try a cigarette, but usually she doesn't smoke. Patricia is hardly ever seen nude, but recently she has started wearing *only* skirts.

Betty is a very, very important character. She is a chimpanzee. She appears sometimes as just plain Betty; sometimes she appears as Naughty Betty. Naughty Betty is employed in a ladies' shoe store in Nebraska, where she helps the farm ladies try on their selections. When she is playing Betty, she is a girl chimp who is real cute and wild, dangerously adventurous, and absolutely not to be trusted. She plays the prankster, trickster, and tease. And

she often acts as a voyeur, especially for me, but also especially for Mrs. Jenkins.

Jimmy is also a chimpanzee and another important character. He was adopted by Patricia and Mrs. Jenkins not long after their move to Arkansas. At different times he can be an emissary, a reporter, a scout, an entertainer, a buffoon, or a pet. Most of his actions are on behalf of Mrs. Jenkins, but sometimes he acts on his own whim. Currently, he is acting as the judge in the Miss Dog America contest which is going to be a *major* event.*

Cookie, who was mentioned earlier in connection with Shirley and Mrs. White/Aunt White, has a sweet and naive nature which has made her a favorite pet of all the other pets. She truly believes that everything is magic and filled with the presence of God. So, while she is included in the activities of all the others, she is never bad or naughty, and she only participates in the hallway escapades from the periphery.

Helen and Helen are major characters. They are Siamese-twin Arkansas bulldogs, joined at the mind at birth but capable of separating at will, who can—and do—appear solo from time to time. Sometimes they join in the activities in Mrs. Jenkins' hallway, but they are rather aloof by nature and usually originate their own episodes. One Helen is so good that she borders on the religious while the other Helen is only semi-good.

Beverly is an important character, too. She is a big, fat, naive ape girl. It is not known if she is 15 years old or 150 years old. Although she appears infrequently, Jimmy, Betty, and Naughty Betty all find her to be an endless source of amusement because she believes everything she is told. She often gets

*The contestants are going to be all the characters in Mrs. Jenkins' hallway, even though they are not all dogs. The contest is going to be held late at night. It is going to be interrupted by the high wind that blows through the hall. All the cigarette butts and bits and pieces of food and watermelon—and everything that is strewn along the floor—is going to get whipped up into the air and bang against the walls and scar them even more than they already are. It is going to be a disruptive time, but then everything will calm down again. And, when it does, a new Miss Dog America will have been chosen.

invited to Mrs. Jenkins' hallway with the promise that she will see something special. Even though she has been fooled many times, Beverly still thinks she will indeed see something special. Naturally, what she gets to see is something really dumb and crumby.*

Gladys and Judy—Sisters-of-Necessity are fat, blond, Siamese-twin farm cats, who live out in the yard around Mrs. Jenkins' house and sometimes get in the hallway. Gladys is the feline reincarnation of Gladys Atlas and Judy is the pet cat of Mrs. White/Aunt White.

Richard and Beth are Siamese-twin King Charles spaniels. Like Cookie, they are sweet, naive, not too bright, but real sweethearts. They make no distinction between anything good or anything bad. And, although Richard believes everything, he is perpetually in a state of surprise. His eyes are always bugged out. He never appears nude. While both Richard and Beth are naive, Beth is really dumb and she functions more as a needless accessory than any other character. Although they are both almost totally passive, their lack of alertness is not dangerous.

Kathleen is a character that appears every once in a while throughout the story—past and present. She is a white cat and she is *never* naughty. She is *absolutely* spiritual, and she is always seen observing what goes on with childlike faith and wonderment, believing everything she sees. She has lots of friends—usually other cats. And, when Kathleen does not appear in a painting but another cat does, it is usually referred to as Kathleen's friend—or "a friend."

This, then, is what happens in Mrs. Jenkins' house: The hallway is a clear-

*In a painting currently in progress chronicling the Miss Dog America contest, Beverly stumbles by accident into the dressing room of Miss Pennsylvania. In this painting, Beverly is pushed up against the wall and is surrounded by a swarm of yellow Eberhard-Faber pencils. She has a distasteful look on her face and her bottom lip is sticking out.

inghouse. When the situation there gets too congested, too convoluted, too elaborately out-of-hand, a big wind comes up and clears it all up. Everything that goes on in there borders on being naughty. Everything that goes on in there is something that should not be seen, but Mrs. Jenkins does see it—through the keyhole of her bedroom door. The characters never see her. They are all wildly excited by the possibility of seeing her and frequently peek through her keyhold, but they never really see anything. All they see are the shreds of sewing thread and bits of bias tape that get whipped up into the air by the fan in Mrs. Jenkins' room.

Every once in a while, the electric fan will whip up one of Mrs. Jenkins' cigarette butts and it will be blown out the keyhole. All the characters will be standing around outside and they will see it come through and they will all giggle and just go wild, like apes in a tornado in the zoo. The noise they make causes them to fight and get crazy for a while. Then it all settles down again. Then a new episode begins. Sometimes the episodes are real simple. Maybe Helen will balance a baby bottle on her head while all the other characters look on in amazement. Just a quiet happening. But this upcoming Miss Dog America contest is going to be a *big* pageant, and everybody is getting steamed up for it.

So stay tuned.

INTRODUCTION

There is a dark and ominous place in the American psyche where the two roots of our culture—the twin atavisms of our European heritage and our aboriginal impulses, that which civilizes and socializes us and that which prompts primal visions and our stubborn individualism—converge. And, although this psychic *terra incognita*, readily apparent in the literature and art of Latin America, is more covertly disclosed in North American literature and art, a rich and continuous tradition of storytelling and imagery attests to the persistent presence of a distinctly American preoccupation with the bizarre, mysterious, and fantastical, simmering just under the surface of our comfortable pragmatism. This preoccupation manifests itself in the poetry and tales of Edgar Allan Poe, the novels and stories of Nathaniel Hawthorne, Washington Irving, H. P. Lovecraft, William Faulkner, and more recently in the fictions of Flannery O'Connor, Joyce Carol Oates, and Stephen King. Nowhere is this curious mix of surface realism and its contradictiory subtext more apparent than in the works of American primitive artists such as Rufus Hathaway, Erastus Salisbury Field, Edward Hicks, and Henry Church. So, too, even the supremely realistic works of Grant Wood, Andrew Wyeth, and Edward Hopper provoke the uneasy suspicion that something unnamed and, perhaps, unknowable lurks beyond, beneath, or just outside what the eye can see, something that is the antithesis of what is seen.

The American preoccupation with fantasy nonetheless remained simply that until the early 20th century, when art in this country became increasingly responsive to the European avant-garde movements and the possibility of a less factual pictoriality grew. But, for the most part, this response tended in the direction of abstraction; the Abstract Expressionists' achievement in the 1940s and 1950s, to cite the clearest example, overshadowed the accomplishment of more stylistically literal American inheritors of Surrealism. Further-

more, most of those more literal American surrealists hedged their own bets, tending either to a kind of enhanced realism—''magic realism,'' as it has been called—or to an allegorical referentiality that did not so much unleash the subconscious as probe beneath it in order to explore more fully the mysteries and complexities of the ''human condition.''

The illustrative mode in American art has tended to draw on literal perception rather than on imagination, as if the expectations and demands on artists were either to report what they saw or just to paint. Just the facts, please, whether they be the facts your eyes see or the facts of your materials themselves, and leave the subconscious out of it.

But in the 1960s, popular taste in America allowed for a readier response to purely imaginative image-making. The interest in artists such as Salvador Dali and René Magritte resulted from an explosion of interest in art generally as well as from an expanding curiosity about the paranormal and the philosophical ramifications (rather than merely the practices and results) of nonrational and non-Western belief systems. By the end of that decade, in various centers of art activity, it was not merely acceptable but normal practice to make art that consisted of optically cohesive but physically unlikely collections of beings, objects, and events. Funk art, derived from the comics and other popular sources of visual narrative, was one manifestation of this growing anti-mainstream tendency in American art. But more realistic approaches to the ''surreal'' also arose, not just among so-called primitive or faux-naive artists but from painters with highly accomplished techniques and little interest in the trends that apparently dominated American art at that time. Such artists felt no affinity for modernist abstraction, nor for the nonpictorial intellectualized abstraction of Minimalism and Conceptual art, but neither were they satisfied with historically retardataire and academic versions of realism being pursued by so many others. Artists (primarily but not exclusively in California) who were associated, however tangentially, with the burgeoning interest in psychedelic drugs and countercultural

lifestyle (William Allan and Bill Martin, for example) developed a pictorial approach that combined extreme verisimilitude with phenomenological improbability. Painters working at the same time in the Midwest—notably in and around Chicago, Indianapolis, and St. Louis—developed similar, if more painterly, styles. Among these were Seymour Rosofsky, June Leaf, James McGarrell, and Robert Barnes. Individuals working in centers as disparate as Philadelphia, Albuquerque, New Orleans, and Minneapolis began moving from Pop art and Photo-Realism toward a less literal use of illusionistic pictorial realism. By the early 1970s, this approach could be seen almost as a trend, although it was recognized less as a "movement" in its own right than as a series of manifestations within other movements—a more realistic Funk, for example, or a kind of "Photo-Surrealism." However, even though it was made possible by the example set by the French Surrealists, it was not surrealism per se, but rather something closer to "visionary" or "uneasy" realism.

"I don't think my work is surrealism," Donald Roller Wilson has said. "Whenever some event 'appears' to be surrealistic, it can usually be explained as being caused by natural phenomena. Like a 'floating' [cigarette] butt or match or melon plug [that] is not floating at all—there is simply a brief, strong wind which whips it up into the air."[1] Roller Wilson's disavowal of surrealism is telling enough, but his insistence that the apparitions and incidents in his pictures are just "caused by natural phenomena" slyly sets up a cognitive dissonance. As he has rendered them, the airborne objects in his paintings do not seem as if they are simply riding updrafts; most seem suspended in midair, perhaps transfixed there by the power or mere presence of one of his anthropomorphized animals, while others describe distinct trajectories, arcs inscribed with laserlike precision on the flat surface of his otherwise illusionistic pictures.

Roller Wilson is a storyteller in the Southern tradition, as loquacious and rivetingly episodic as William Faulkner or Joel Chandler Harris. But he is also

a fantasist of the first order, able to conjure myths and legends out of the most trivial incidents and intimate inventions. In telling his hilariously yet touchingly detailed stories, he capitalizes on his virtuosic command of realist painting technique to set such improbable events into that much starker contrast with mundane reality.[2] Gazing at a Roller Wilson picture, we cannot believe our eyes, nor can we *not* believe them. He achieves an interplay between image and meaning that is startling in its vertiginous collapse of contradictory factors into unified pictorial concepts and unparalleled (at least in the modern era) in its narrative conceit of presenting in his pictures an ongoing tale, a tale at once entirely cryptic and thoroughly obvious. His astonishing technique makes each detail seem equally important to the ''plot.''

Everyone and everything in a Roller Wilson picture has its reasons for being there. Their iconographic significance could be described and analyzed exhaustively; but such description and analysis beg the question, for the deduction of those reasons is best left to the viewer. More than in most contemporary art, the viewer's task here is one of recognition—of figures, of events, of leitmotifs—rather than interpretation. Not all ghost stories or science-fiction novels convey moral lessons. Roller Wilson tells his story or stories not for the sake of an underlying allegory or higher moral purpose but just for the sake of telling them. His accounts of Mrs. White (who is in fact Aunt White, as well), Mrs. Jenkins, Betty, Beverly, Loretta, Jimmy, Cookie, and the rest of the cast (or, if you prefer, menagerie) are full of the foibles of humanity and the sins that the flesh is heir to. But such age-old human themes simply provide a better ''read,'' a more credible story. An analysis of these pictures, beyond a basic key to the characters, would be equivalent to explaining a joke by repeating the punch line.[3] In their unusual emphasis on narrative, and their rendition of that narrative through meticulous detail and a context of fantasy in which transformation from the real world is constantly presumed, Roller Wilson's pictures, singly and together, ''tell'' themselves. What remains

to be analyzed is simply *how* they tell what they tell.

In its lifelike style of rendering, Roller Wilson's art recalls not just hyperrealist 19th-century academicism such as the work of Ingres or Gérôme, but the even earlier work of northern Renaissance masters—less, however, that of Hieronymous Bosch or Pieter Breughel than that of "realists" like Jan van Eyck and Albrecht Dürer. In his work of the late 1960s, Roller Wilson demonstrated his affinities with this tradition by painting scenes that combine domestic interiors and landscapes, mistily elaborate dream-views crammed with peculiar still- (and not-so-still-) life details and broken up by floating walls in which windows and window sills recur. These recall the Flemish and Dutch tradition of depicting ornate interiors with walls punctuated by deep-set windows, which let in natural light and through which can often be seen a panoramic landscape or cityscape. In 1970, Roller Wilson moved on to different modes of historical pictorial artifice, most notably the rendition of drapery to suggest a proscenium space. The noble poses and formal garb of many of the sitters in these imaginary portraits have their source in the "stagey" tradition of late-18th- and early-19th-century European (and American) portraiture. However, instead of rendering a countess or a general, or their modern-day equivalents, he depicted white-haired apes dressed in that finery and posing with startling dignity. There began the anthropomorphic transformations that Roller Wilson has continued to depict ever since.

The years 1971-78 saw an outpouring of pictures that are baroque both in image and in narrative. The compositions are dense, with a vast array of objects and characters crowded into a shallow fictive space. Even in the many works in which landscape vistas open up behind the foreground "stage" of action, it is clear that those vistas, like the ones in the classical portraits that Roller Wilson was emulating, function as backdrops. They may *refer* to deep space, but in the context of the apparent story line they exist on another plane altogether, a plane in which the reveries of the main characters take place.

Similarly, the objects that fill the foreground interiors—fruit, flowers, skulls, oriental carpets, animal-skin rugs—are projections of the imagination rather than literal depictions of real rooms. The art-historical references help keep the busy, information-laden paintings from tumbling headlong into bathos; and the outdoor scenes that open up the space in the picture where a wall would normally be, dropping away from these unlikely collections of unrelated objects, give such a mass of stuff some breathing room. And these pictures—and we—definitely need breathing room.

THE MAN HAS LEFT THE MOON..., 1974, [p. 46] combines still-life, portrait, and genre elements in a web of information across and through which the eye can play endlessly, always discovering new details, new references, and new cross-connections. Many of these elements are traditional to painting, but just as many are from contemporary American culture. As with most of Wilson's works from this period, the title is as elaborate, extensive, and full of information as the picture itself. The full title is a veritable poem:

THE MAN HAS LEFT THE MOON TONIGHT
HE TRAINS SOME BEAMS UPON THE FACE
OF GLADYS ATLAS IN THESE WOODS;
HEADS OF CABBAGE—(HEADS OF STATE)

A viewer can identify Gladys Atlas quite readily, the human figure at left, obviously moonstruck. The heads of cabbage are center stage, mixed in with the "heads of state"—a clever way of referring to the skulls, one that amplifies their *memento mori* role. The cabbages and skulls have appeared in earlier paintings; so has the sock doll named Shirley, dressed in her blue dress, and here draped over a new icon: the cat smoking a cigarette, an image that is to gain greatly in prominence in paintings of the following years. Perhaps for the first time in a major chapter from the ongoing tale the apes that have until now been playing central roles—indeed, dominating the proceedings—are ab-

sent here. They appear several more times after this but cease to dominate center stage, making way for the cats, dogs, monkeys, and chimpanzees that populate Roller Wilson's fables in the later 1970s and '80s.

In its inclusion of human characters who do not appear previously (or subsequently) in Wilson's evolving story, WAITING OUTSIDE OUR HOME BY THE POND..., 1977, [p. 43] is representative of paintings that are a "vacation from that story."[5] In fact, the hats and doctor's satchel pertain to the doctor's visit to the deathbed of one of the initial main characters (Aunt White). The fellow in the dress may be the doctor. Then, again, he may be the angel of death. Or perhaps that is the role played by the young woman across from him; her outfit, too, is black. Once more, the iconography in Roller Wilson's pictures begs to be deciphered but defies decoding, at least beyond the keys and clues that the artist himself provides. The indicators confound as much as they inform us, and create that characteristic Roller Wilson effect of the simultaneous logic and illogic of the narration.

Wilson continued to create these ornately staged scenes through the '70s; but, beginning in 1977 with some rather plain portraits of upstanding feline citizens painted on small oval panels, such background detail disappears from most of his later works, which are simpler and less ostentatiously theatrical.

On each side of the foreground of WAITING OUTSIDE OUR HOME BY THE POND... is a corrugated cardboard box out of which peer the heads of little cats—two on one side and one on the other. Here, two of the cats are wearing a dress ruff and smoking a cigarette (the same smoking cat motif that first appeared in THE MAN HAS LEFT THE MOON...). Roller Wilson had done a small oval portrait of a smoking cat in February of that same year, LITTLE LORETTA—MY NEW FRIEND...[p. 44]—returning to the miniature format for the first time since 1972 (when he rendered several images of watermelon slices resting on fabric)—and did several more later that year. Likewise, 1977 saw the appearance of similar portraits of dogs—without cigarettes, but dressed up

every bit as humanly as the felines; several of these decked-out hounds show up in his larger pictures of that period, too. Note, for example, the dog popping up and out of the baby carriage (in more ways than one) in THE CLONE; THE FUSE; AND SISTER DINAH MIGHT..., 1978, [p. 56] while peering with anxiety and undisguised interest at the rocket and roman candles (dynamite?) arrayed before him. Despite his halo, he displays with ardor a particular lack of innocence—a Freudian joke that Roller Wilson amplifies and enlarges (so to speak) through several telling details. Rather more sanguine is the nun enthroned on the easy chair, perhaps because the specter of death next to her— the "head of state" referred to in the title—hanging from the lamp by her side provides her adequate protection.[6]

In the early 1980s, Roller Wilson began to reduce the size and complexity of his pictures and to refine further his already precise technique. By the outset of the decade, he had established a greater uniformity in his palette, eschewing the saturated, sometimes brilliant or saccharine color schemes of the earlier work for tonal range of grays, browns, and (usually muted) red, highlighted with a vivid chiaroscuro. Actually, "melodramatic" might better describe the play of light and shadow, a theatrical highlighting invariably evoking the nighttime and suggesting in its localized lighting not Caravaggio so much as Georges de la Tour. The staginess of this general format is offset by Roller Wilson's elimination, after 1981, of the kind of elaborate background views that he had used in his earlier, larger work. Those of Roller Wilson's characters who have lasted from the pictures of the 1970s into those of the 1980s are dogs, cats, and especially simians, all of which have been given human characteristics. But real human figures were also included in the works of the '70s as an odd, unsettling counterpoint to the humanized mammals. After 1982, the human figure also disappeared from the pictures, replaced entirely by animals dressed and posed as humans., In other works, there are no figures at all, but he has filled the pictures with objects that testify to human presence. These

still lifes function as *mementi vivende*, in contrast to the *mementi more* of the '70s paintings, with their skulls and other symbols of death.

Such symbols have played an iconographic role throughout Western art, and it is clear that Roller Wilson refers consciously to that tradition when he includes skulls in his pictures and when he paints abandoned-table still lifes, which carry on the theme of *tempus fugit* found in painting at least since 17th-century Holland. In our century, these conventions have become the domain of academics and deliberate archaists. Especially in the current context of postmodernist historicism, such archaism is not uncommon practice. The best practitioners engage in it in order to explore the resonance of ancient themes and icons in contemporary contexts, to wrestle with the formal challenges invariably posed by such advanced academic formulas, and to pay loving homage to the tradition and its masters. Roller Wilson can be counted among this group, but he differs from most of the others in one obvious way: he is not primarily motivated or preoccupied by the issue of historical citation per se, using it more as a support for his storytelling and picture-making.

Within the last several years, Roller Wilson has been telling his tales by working within a relatively restricted set of formal themes and variations, in which the crowded dinner tables figure prominently. The "simple portrait" also predominates as a thematic format, recalling austerely colored but richly detailed northern European Renaissance and Baroque portraiture. The "Old Master gray" tone providing the uninflected backdrop to the sitters harks back to 17th-century Dutch portraits, notably husband-and-wife pairs, while the small scale of the paintings recalls earlier panel portraits by German masters such as Hans Holbein. Even the lacy collar worn by many of Roller Wilson's female protagonists is reminiscent of the clothing worn by 17th-century burghers and their wives.

One especially droll manner in which Wilson maintains his narrative through art-historical reference is his use of increasingly elaborate frames as

integral elements of the paintings. This new development in his works began as he simplified the overall images that he was painting on the canvases. As his pictures became plainer, the frames became more and more prominent and elaborate. Many are upholstered (echoing the clothing worn by so many of the animals in the portraits), while others are painted with gold leaf. But most of them bear inscriptions—phrases that are part of the picture's legend scrawled in red directly on the painting itself (for example, the phrase "God is near" in MRS. JENKINS HAD TURNED... [p. 92] or "just imagine your message in this space" in HUMPTY-DUMPTY'S LATE-NIGHT SNACK [p. 107], both 1986. His conceit of inscribing title, date of completion, and his signature in a neatly lettered legend above the subject's head in some works recapitulates the style of inscription in northern European portrait paintings.

These legends provide the '80s paintings with a certain sense of continuity. Each picture comes off less like a book or chapter on its own—as the 1970s works usually seem to—and more like an entry in a daybook. The diaristic quality is underscored by the prominence of the date and the exact time of each painting's completion in its narrative legend, and by the sense that each work is a scene from a single story involving a continuing cast of characters. There actually is a plot, or at least an ongoing situation—rather like a fevered, inverted television sitcom acted out by animals, apparently in the hallway and kitchen of a little shack in Arkansas inhabited by one Mrs. Jenkins, a refugee from Manhattan who is over 118 years old. Who is who and doing what to whom is hard to keep straight, even with a hagiography handy. Some viewers familiar with the current New York art scene might find references to a particularly prominent art dealer who exhibited Roller Wilson's work at one time. (The excitement of this prestigious opportunity provoked a surge of paintings including or referring to a pretty afghan hound named Holly, a "visiting" character to the story.) But the real world dares not otherwise intrude on this mad scenario. By now, the story supports itself. It has its own

motor in the uniformity of Roller Wilson's method of telling its chapters and incidents. At this writing, he is engaged in recounting the "Miss Dog America" contest being held in Mrs. Jenkins' corridor at night as she sleeps (or sews) behind her closed bedroom door. Who knows, however, where the convoluted tale will lead?

Roller Wilson's whole world, at least in this decade, has thus occupied just the space in and around a shack somewhere in Arkansas. In this isolated and restricted space he has created an odd realm where the Southern equivalent of fairies and leprechauns come out to play when the old hermits and shut-ins turn their backs or slumber. But the persuasiveness of these paintings comes not from the specificity of locale, however picturesque. It comes from the universality of their atmosphere, from the logical cohesion in the story line that binds them together, no matter how illogical the individual scenes might seem.

NOTES

1. As quoted by Leigh A. Morse in *Donald Roller Wilson: Mrs. Jenkins' Hallway*, New York: Coe Kerr Gallery, 1987, n.p.

2. That phenomenal precision, enhanced by a backlit scheme, suggests a basic approach of the aforementioned American "magic realists" of the 1940s and '50s—painters such as Jared French, Paul Cadmus, Eugene Berman, and Paul Tchelitchew, who tempered the orthodoxies of French Surrealism with more conventionally romantic or realistic subjects and approaches and a more self-conscious sense of staginess. (Berman was a noted stage designer as well.) The more grotesque work of Ivan LeLorraine Albright (who did not work in New York, as the Magic Realists did, but in Chicago) also comes to mind. A further parallel can be drawn between Roller Wilson and the Dutch school of magic realism, a localized offshoot of Surrealism that flourished in the 1930s. In the paintings of Charley Toorop, Carel Willink, Dick Ket, and other Dutch magic realists, classic themes, romantic treatments, and realist, often Hopperesque, subjects converge, rendered in much the same incandescent hyper-precision that Roller Wilson employs.

3. One can say the same about the work of Mark Tansey, the best known of a new breed of "uneasy realists" that has emerged out of the New York mainstream.

4. The full title of the painting is:
> AND LITTLE COOKIE LICKED HER LIPS
> AND LINCOLN'S CHIN WAS CLEAN
> AND HIS PANTS—(BOTH PAIRS)—WERE STEAMING AT THE BEAMS
>
> A WITCH'S BONEY TOES HAD SPREAD
> ALL WHITE—AND HARD, AND LEAN;
> ONE LEG ALONE: HER BROOM HAD BEEN BETWEEN

5. The full title is:
> WAITING OUTSIDE OUR HOME BY THE POND
>
> HIS PENCIL MOVED INSIDE OUR EARS
> IT MARKED SOME CLEAR DIRECTIONS:
> THE DOCTOR CAME, BUT LEFT HIS LEATHER CASE;
> DOWN IN THE STICKS AND ROCKS AND LEAVES.
> HE CAME IN NEAR PERFECTION—
> HIS CRYSTAL BALL IS RESTING ON ITS BASE
>
> AND THERE'S A GIRL IN BLACK IN MARY'S PLACE

6. The full title is:
> THE CLONE; THE FUSE; AND SISTER DINAH MIGHT
>
> ON YERBA BUENA ISLAND
> (WHERE THE GOLDEN GATE *HAD* BEEN)
> BEFORE THE SILVER TUBE HAD LANDED IN THE NIGHT,
> OUR HEAD OF STATE WAS HANGING
> DRY AS A BONE—BONE TO SEED;
> IT HUNG BESIDE THE HEAD OF SISTER DINAH MIGHT

The inscription following the signature only hints at what provokes the dog's passion: THIS BOX [on which the inscription appears] HAS NO BRAND NAME ON IT BECAUSE THERE IS NO WAY TO DESCRIBE THE CONTENTS...BUT THE DOG NOSE.

THE PAINTINGS OF DONALD ROLLER WILSON

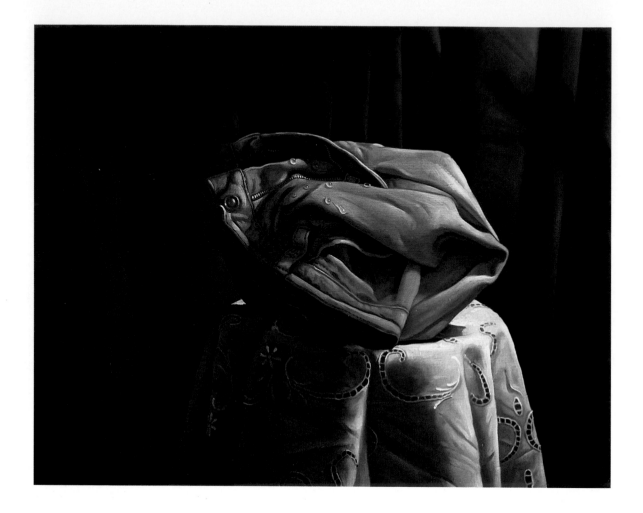

BLUE ROAST: ROLLED RUMP

THE SHADOW OF THE BONE IS CURVED;
IT FALLS ALONG THE FOLDS
OF DRAPES WHICH HANG BEHIND THE STEAMING JEANS

Oil on canvas
16 x 20 inches
Signed, lower left:
DONALD ROLLER WILSON
WEDNESDAY • JUNE 6
1978 • 4:27P.M. ♥

Collection: Mr. Douglas Cramer, Los Angeles, California

THE HAT THE HEAD OF STATE HAS LEFT

Oil on canvas
18 x 26 inches
Signed, lower left:
DONALD ROLLER WILSON
7:38P.M. SATURDAY •
SEPTEMBER 3 • 1977

Collection: Mr. & Mrs. Weldon Steinman

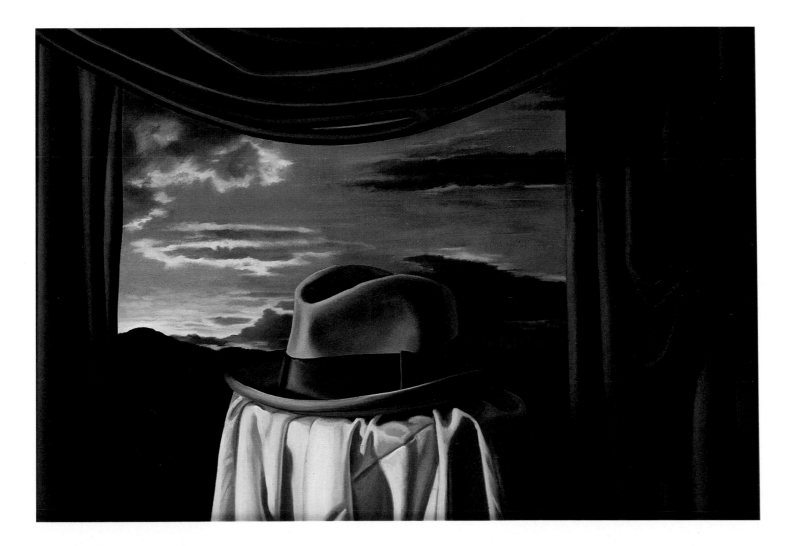

SHIRLEY'S LAST SUPPER PRIOR TO HER RETURN FROM PARADISE

BEFORE HER ENTRANCE THROUGH THE GATE
BETWEEN THE LEGS OF GLADYS
BEFORE THE CALL WHICH CAME—(PLACED BY HER HOST)

SHE PASSED A MAN WHO HAD TWO HEADS
WHO ALSO CAME THROUGH GLADYS
BUT, IN REVERSE—THE SON—(THE HOLY GHOST)

Oil on canvas
40 x 50 inches
Signed, upper right:
DONALD ROLLER WILSON
TUESDAY • JUNE 20 • 7:03P.M.
1978 ♥ SHIRLEY'S DINNER

Collection: Private

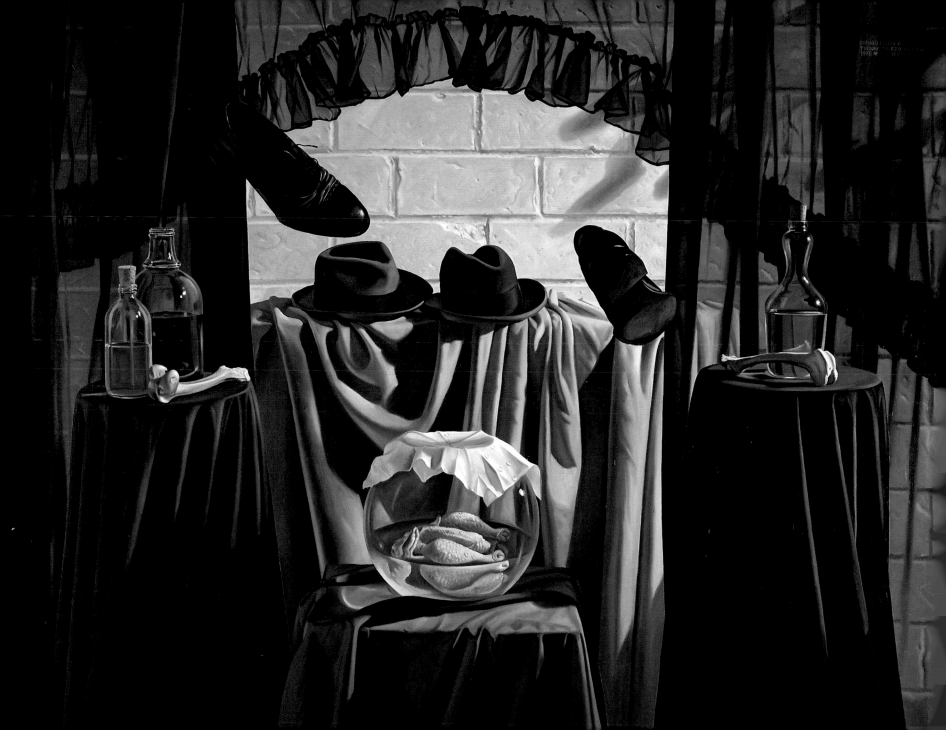

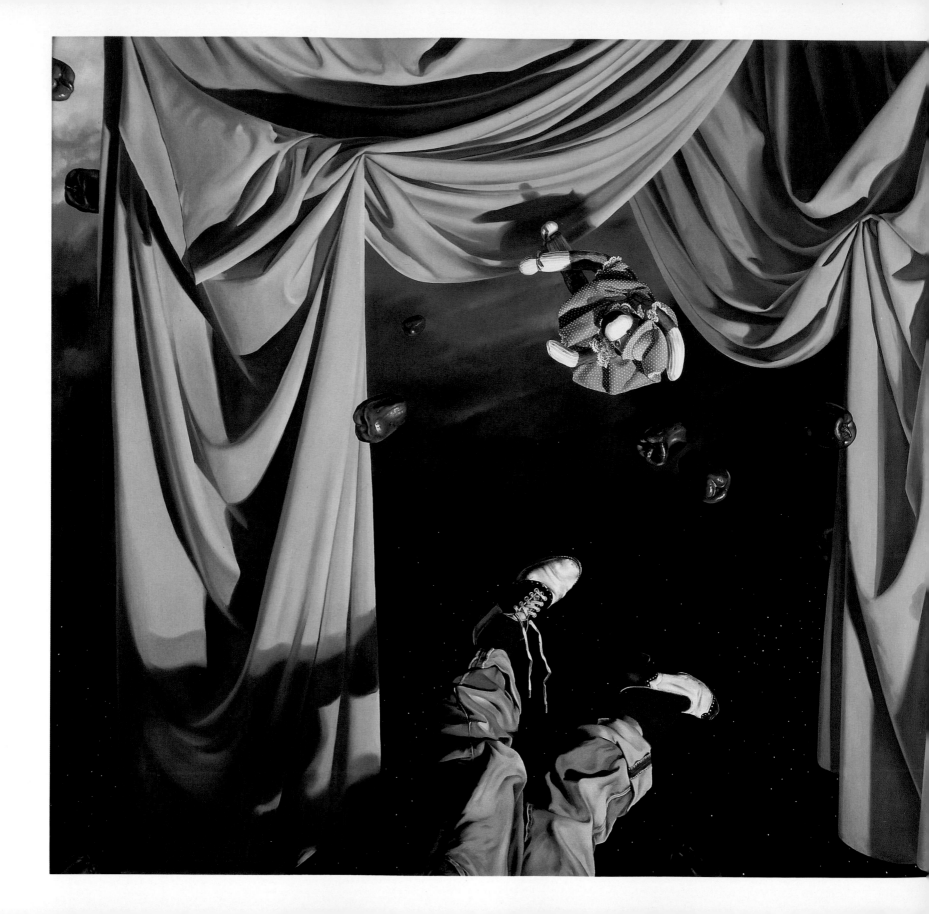

40

THE ENTRANCE OF SHIRLEY INTO PARADISE

THE BAG OF GROCERIES ON THE CHAIR <u>DID</u> SPOIL AND DRIFT AWAY;
DRIFTED TO A PLACE WE CANNOT SEE
THE PARTS MOVED FASTER AS THEY LEFT AND SPREAD INTO A MIST;
SPREAD INTO A PLACE WHERE <u>WE</u> WILL BE
AND WITH THOSE PARTS RESUMMONED BY A CALL <u>HE</u> SURELY PLACED,
(CALLED FROM RESTING TO BE BORN ONCE MORE)
THE FORM OF SHIRLEY—DRESSED THE SAME—BEGAN TO MOVE IN SPACE;
ALONG WITH PEPPERS, TOWARD AN OPEN DOOR

Oil on canvas
50 x 64 inches
Signed, lower left:
DONALD ROLLER WILSON • SATURDAY • OCTOBER 25 •
1975 • THE ENTRANCE OF SHIRLEY INTO PARADISE •
MRS. WHITE HAS REMOVED THE TREES AND THE
HILLS AND, HOPEFULLY, THE CRUMBS FROM THE
CARPETS OF HOME • 2:38P.M.

Collection: Mr. & Mrs. Michael T. Judd

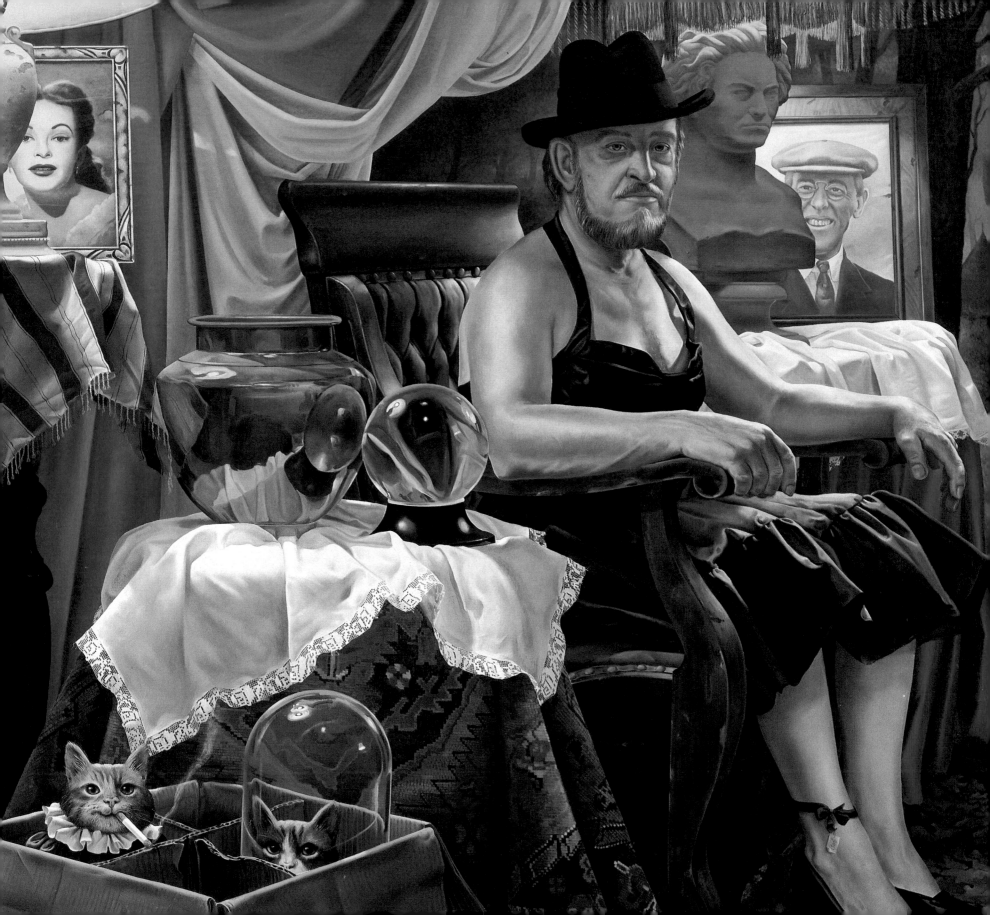

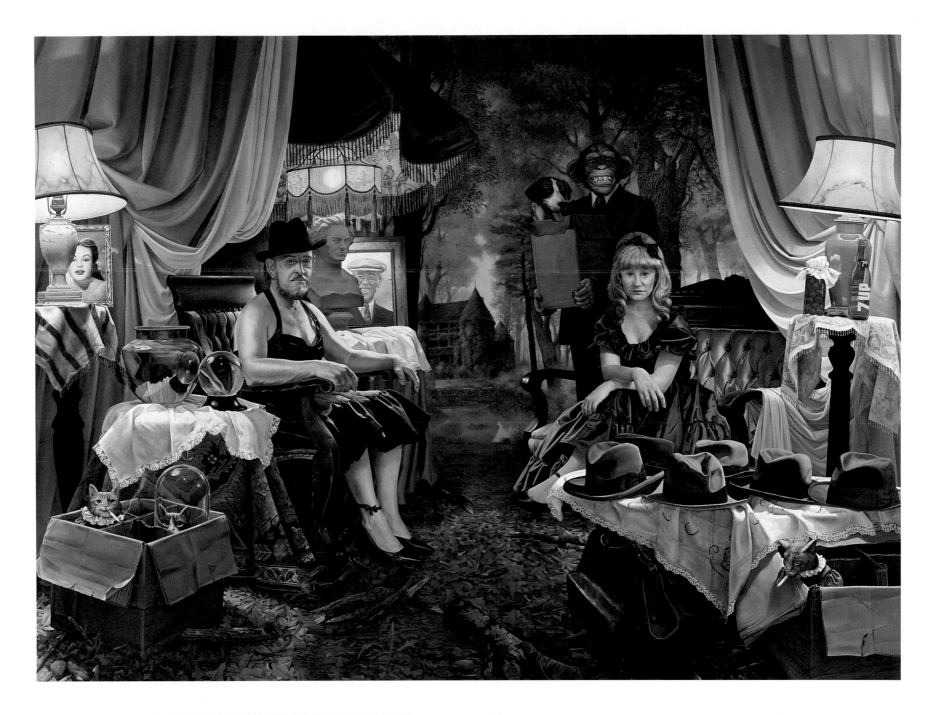

WAITING OUTSIDE OUR HOME BY THE POND

HIS PENCIL MOVED INSIDE OUR EARS
IT MARKED SOME CLEAR DIRECTIONS;
THE DOCTOR CAME, BUT LEFT HIS LEATHER CASE;
DOWN IN THE STICKS AND ROCKS AND LEAVES,
HE CAME IN NEAR PERFECTION—
HIS CRYSTAL BALL IS RESTING ON ITS BASE

AND, THERE'S A GIRL IN BLACK IN MARY'S PLACE

Oil on canvas
75 x 100 inches
Signed, lower right on case:
DONALD ROLLER WILSON
SUNDAY • AUGUST 21 • 10:29P.M. 1977
WAITING OUTSIDE OUR HOME BY THE POND
FOR BOB, MY FRIEND

Collection: Mr. & Mrs. Arthur Goldblum

43

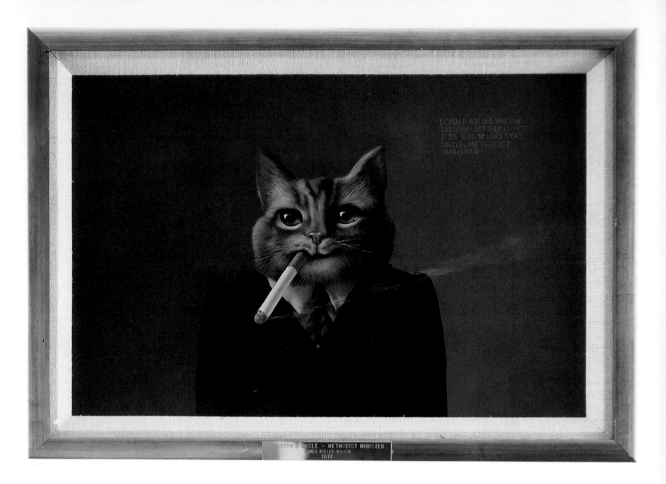

LORETTA'S UNCLE—METHODIST MINISTER

Oil on panel (masonite)
9½ x 14 inches
Signed, upper right:
DONALD ROLLER WILSON
TUESDAY • OCTOBER 11 • 1977
6:35P.M. ♥ LORETTA'S
UNCLE, METHODIST
MINISTER

Collection: Private

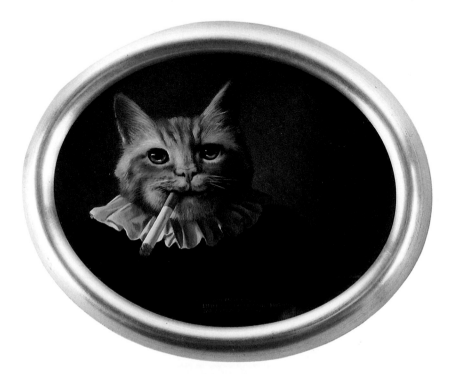

**LITTLE LORETTA—MY NEW FRIEND;
SMOKES AND MEWS,
AND LOOKS—AND THINKS**

Oil on panel (masonite oval)
8 x 10 inches
Signed, lower center:
DONALD ROLLER WILSON
LITTLE LORETTA • MY NEW FRIEND
EARLY FEBRUARY • 1977

Collection: Private

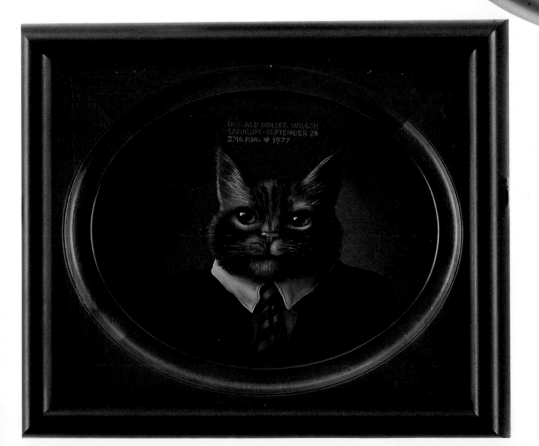

LORETTA'S SISTER PUFFS AND SMOKES;
WEARS A MELON ON HER HEAD

Oil on panel (masonite oval)
11 x 14 inches
Signed, center left:
DONALD ROLLER WILSON
NOVEMBER 23 • 1977

Collection: Private

LORETTA'S FATHER

Oil on panel (masonite oval)
8 x 10 inches
Signed, upper center:
DONALD ROLLER WILSON
SATURDAY • SEPTEMBER 24
2:46P.M. ♥ 1977

Collection: Private

45

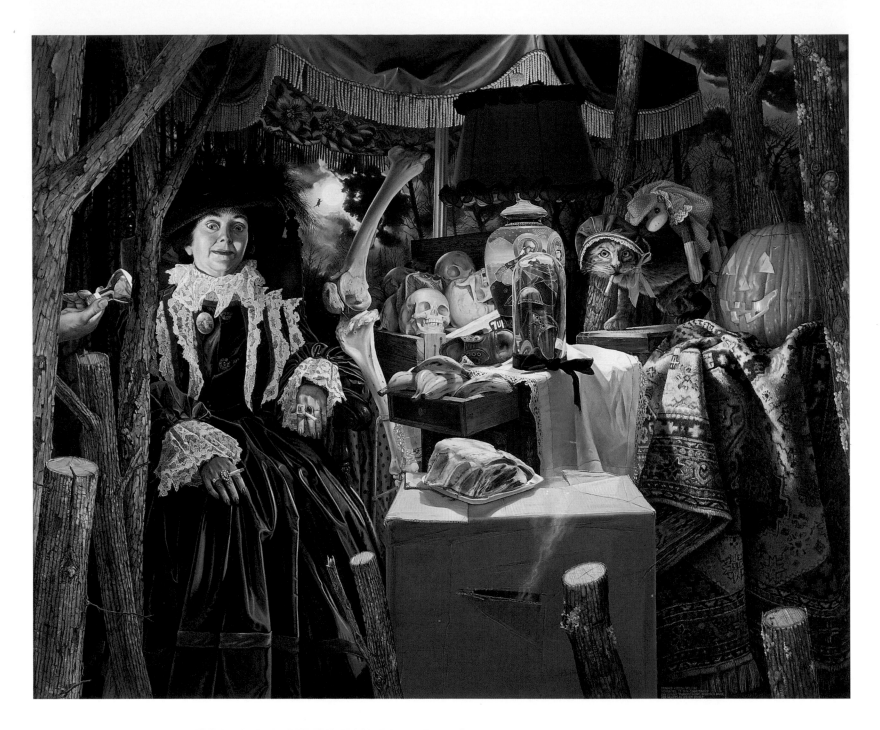

46

THE MAN HAS LEFT THE MOON TONIGHT
HE TRAINS SOME BEAMS UPON THE FACE
OF GLADYS ATLAS IN THESE WOODS;
HEADS OF CABBAGE—(HEADS OF STATE)

Oil on canvas
57 3/8 x 69 inches

Signed, lower right:
DONALD ROLLER WILSON
NOVEMBER 27 • 1974 • SAGGITARIUS
DAY BEFORE THANKSGIVING, WHICH IS DAILY
FOR HEARTS AS OPENED DOORS

Collection: Hirshhorn Museum & Sculpture Garden, Smithsonian
Institution, Washington, D.C.

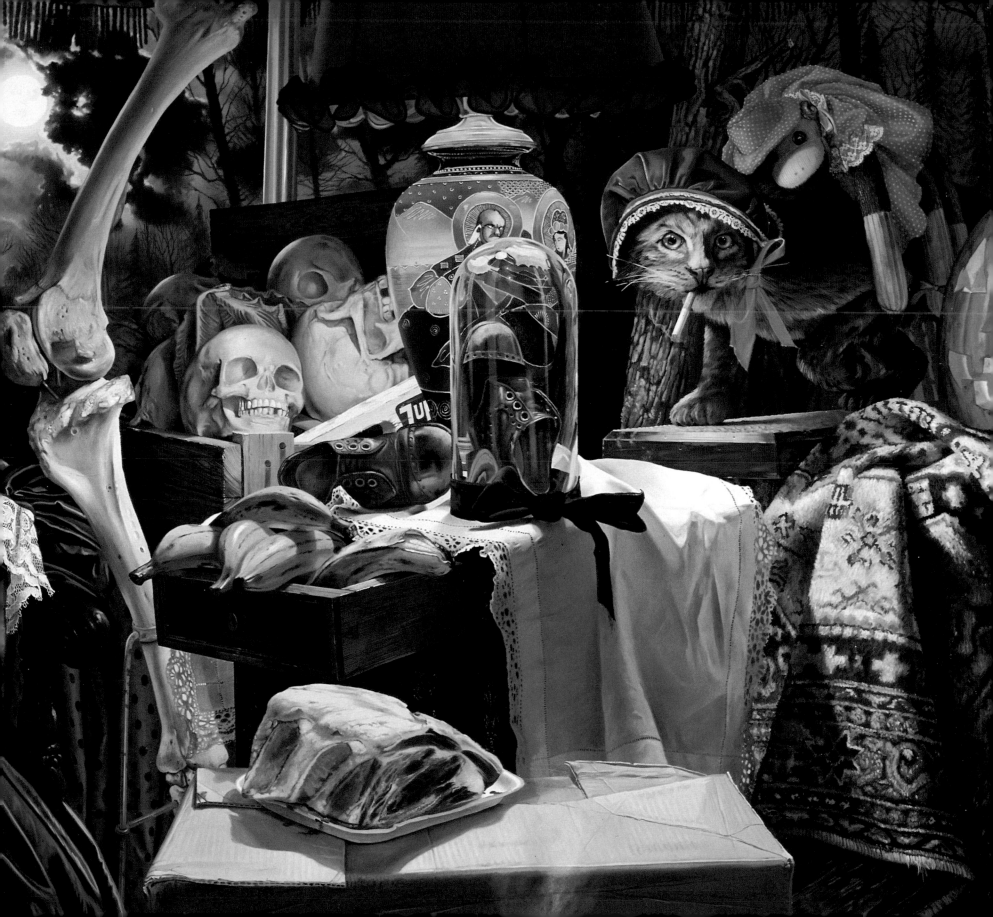

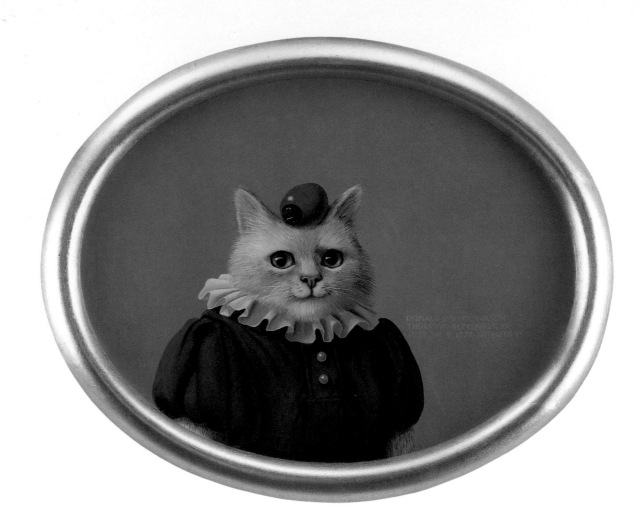

KATHLEEN

Oil on panel (masonite oval)
11 x 14 inches
Signed, center right:
DONALD ROLLER WILSON
THURSDAY • SEPTEMBER 15 •
11:27P.M. ♥ 1977 • KATHLEEN ♥

Collection: Private

48

LITTLE BETTY'S FRIEND IS HERE
HE'S GOING TO LICK HER OLIVE;
HE'S GOING TO CHEW IT TOO—IT SEEMS TO ME

Oil on canvas
14 x 16 inches
Signed, upper left:
DONALD ROLLER WILSON
FRIDAY • NOVEMBER 11 • 1977
4:01P.M.

Collection: Steven & Sandra Rudy

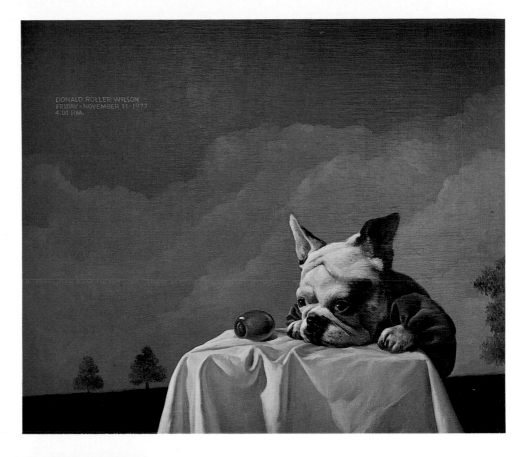

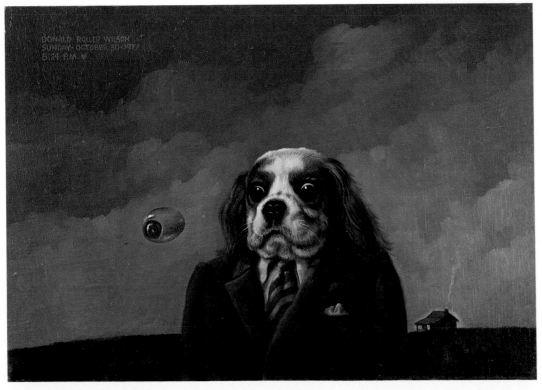

CAME FROM WISHING; ON THE FRONT PORCH
ROLLED ROAST TID-BIT ON MY MIND;
NOT A GREEN ONE: RED-STUFFED GREEN ONE,
WANT A T-BONE—WANT <u>THAT</u> KIND!

Oil on canvas
10 x 14 inches
Signed, upper left:
DONALD ROLLER WILSON
SUNDAY • OCTOBER 30 • 1977
5:24P.M. ♥

Collection: Private

49

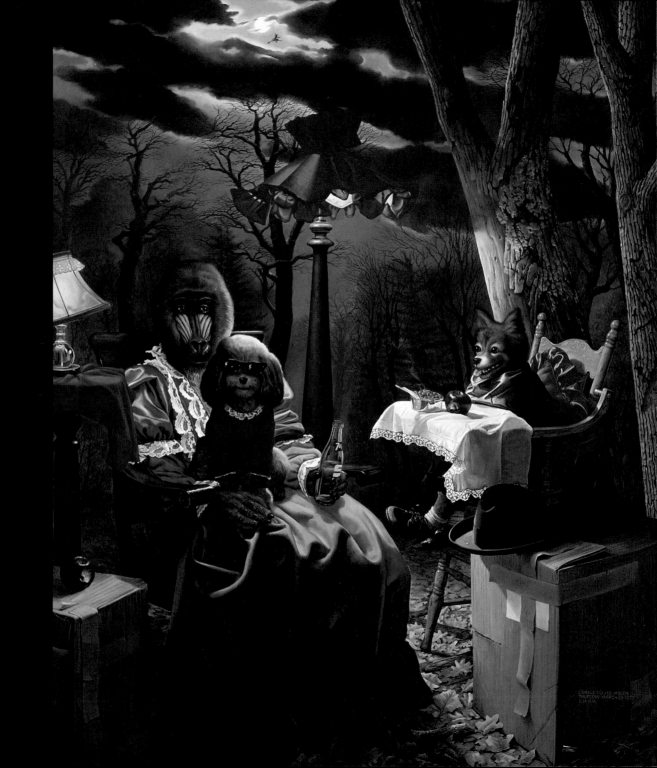

50

THE LAST ZEPPELIN DESTROYED IN THE WAR, ▶
 AT FRIEDRICHSHAFEN

THE HEAD OF STATE HAS LEFT HIS HAT:
A QUEEN HAS COME TO RULE;
HER SILVER SHIP RETURNING TO THE MOON

SHE BROUGHT A DRINK A COW ONCE SIPPED
WHEN TRICKED INSIDE A ROOM;
HER HOLLOW SHIP IS SILVER—LINED WITH TOMBS

Oil on canvas
87 x 60 inches
Signed, lower left:
DONALD ROLLER WILSON • WEDNESDAY •
DECEMBER 22 • 1976 • 3:01P.M. AND
THE RABBIT FOUND HARDWOOD UNDER
THE KITCHEN FLOOR AT 403 WEST SPRING
STREET • WHAT HAVE YOU FOUND?

Collection: Private

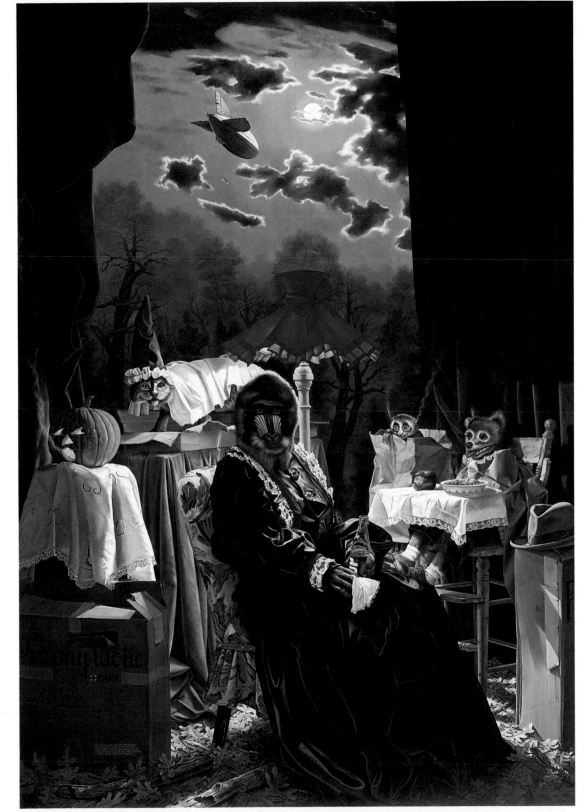

◀ THE SECOND VISIT OF THE QUEEN

THE QUEEN HAD LANDED IN THE NIGHT
SHE FLEW BEHIND A WITCH;
(THE WITCH WENT BACK—SHE FLEW UP TO THE MOON)

THE DRINK WAS ONE A COW ONCE SIPPED
WHEN TRICKED INSIDE A ROOM;
(A TEXAS SHACK ALL SILVER—LINED WITH TOMBS)

Oil on canvas
64 x 50 inches
Signed, lower right on box:
DONALD ROLLER WILSON
THURSDAY • MARCH 29 • 1979
1:14P.M.

Collection: Lonnie & Leonard Hantover

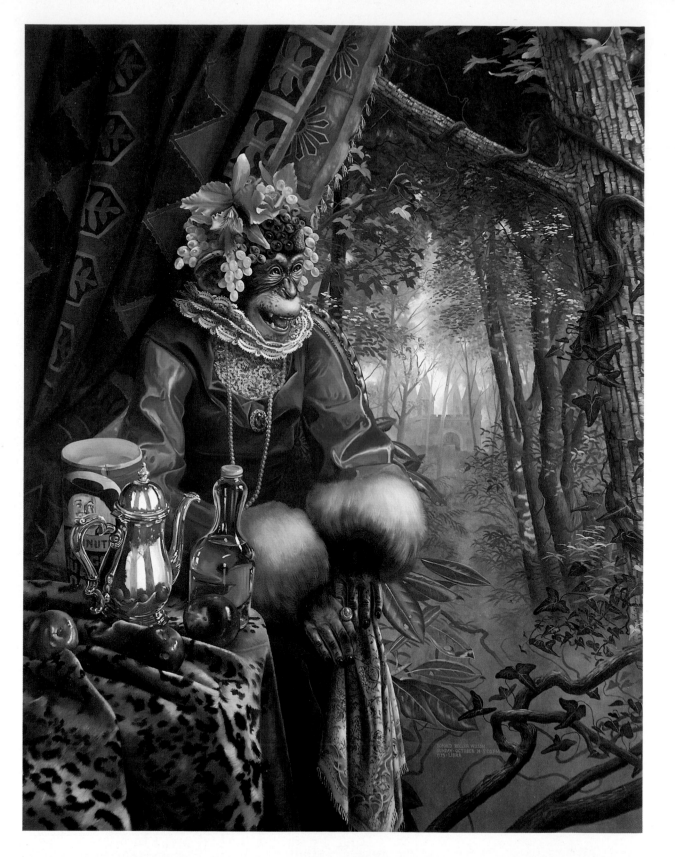

SITTING IN THESE WOODS AND WAITING;
HOPING THAT NO ONE WILL SEE;
SUNLIGHT HITS MY GOLDEN BOTTLE;
HOME IS BACK THERE IN THE TREES

Oil on canvas
58 x 44½ inches
Signed, lower right:
DONALD ROLLER WILSON
SUNDAY • OCTOBER 14 • 3:00P.M
1973 • LIBRA

Collection: Kelly Gale Amen

◄

TWO SWEET SINGERS IN THE WOODS; ►
BETTY JANE AND HAZEL TOO;
SING A SONG BEFORE YOUR WEDDING;
FOREHEAD BLAZING LIKE THE BUSH

Oil on canvas
66 x 60 inches
Signed, lower left:
DONALD ROLLER WILSON
FEBRUARY 7 • AQUARIUS • 1973

Collection: Mrs. Mills Bennett

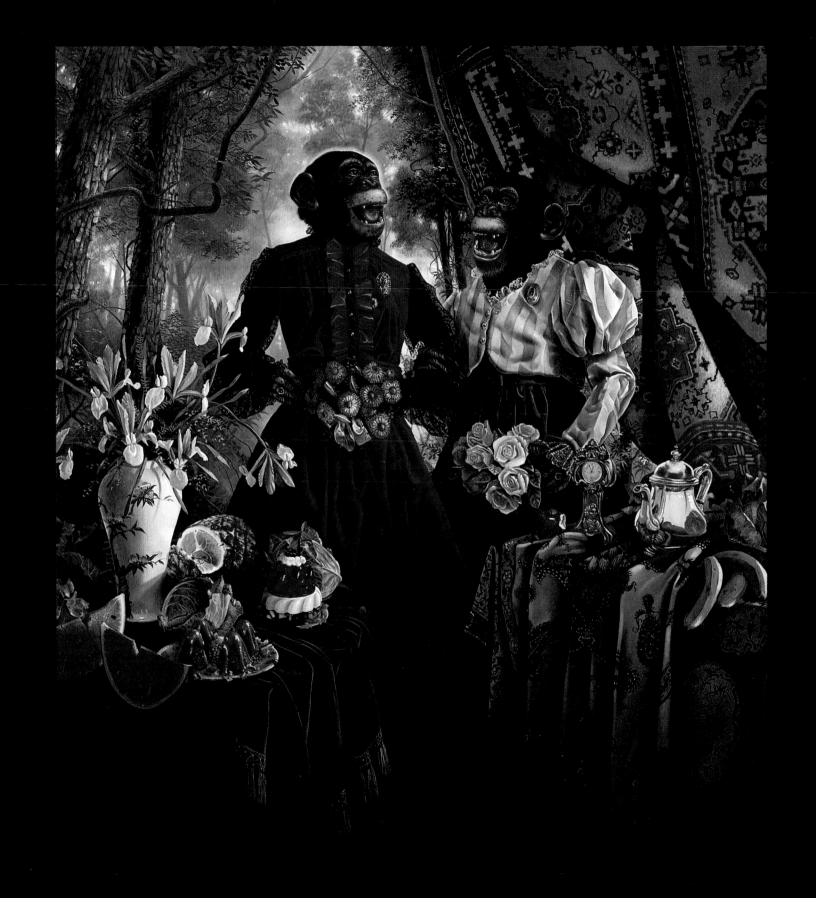

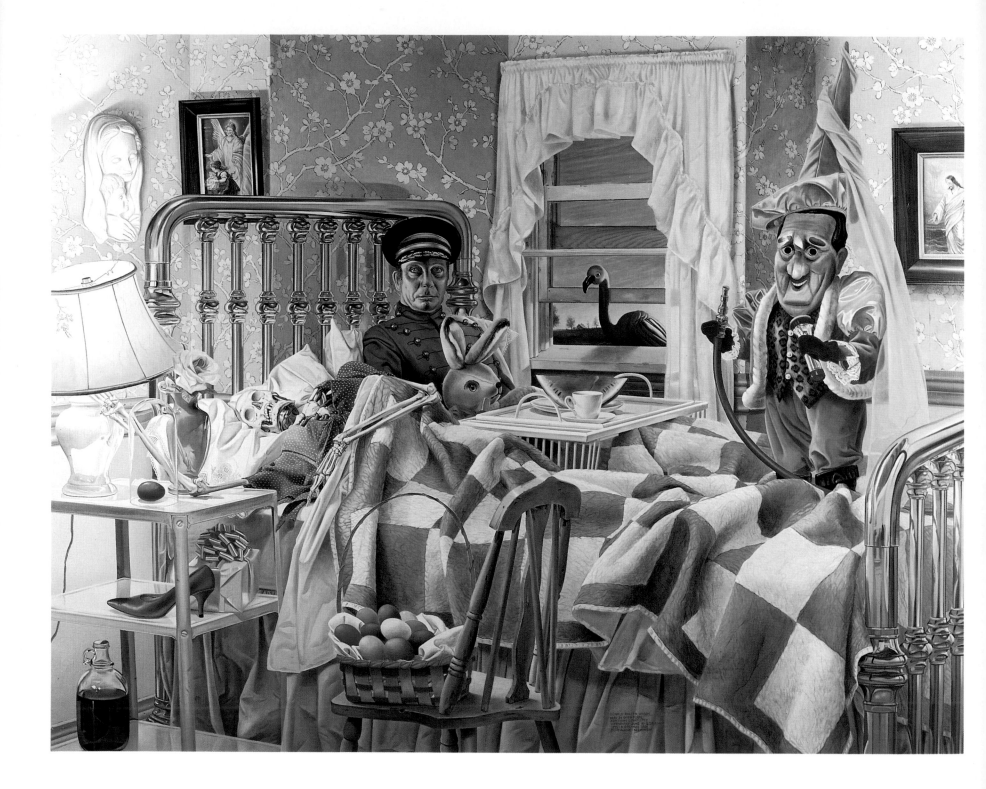

CORI AND RETT HAVE CROSSED A BRIDGE
AN ANGEL WATCHED ABOVE
THE GARDEN BIRD HAS COME ALL HARD AND RED
A MAN OF WAR IS IN HIS PLACE
(PUT OUT THE FIRE OF LOVE)
MY GARDEN HOSE IS WAITING—IN YOUR BED

Oil on canvas
51 x 64 inches
Signed, right center:
DONALD ROLLER WILSON
MAY 24 WITH FINAL
ADDITIONS COMPLETED
WEDNESDAY • JUNE 18 • 8:29P.M. •
1975. A STRANGE TASK
DONE ALONE • SEEMINGLY.

Collection: Private

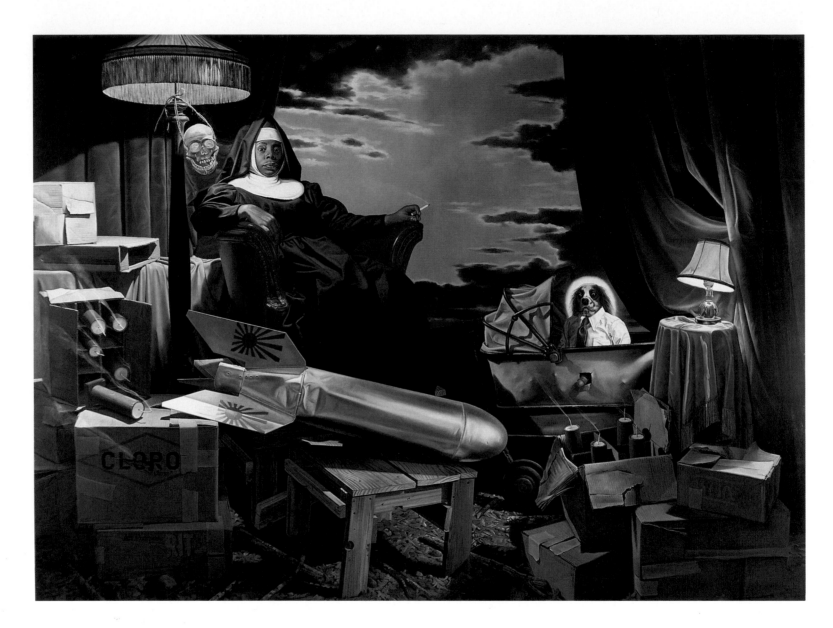

THE CLONE; THE FUSE; AND SISTER DINAH MIGHT

ON YERBA BUENA ISLAND
(WHERE THE GOLDEN GATE <u>HAD</u> BEEN)
BEFORE THE SILVER TUBE HAD LANDED IN THE NIGHT,
OUR HEAD OF STATE WAS HANGING
AS A DRY BONE—GONE TO SEED;
IT HUNG BESIDE THE HEAD OF SISTER DINAH MIGHT

Oil on canvas
64 x 87 inches
Signed, lower right:
DONALD ROLLER WILSON
FRIDAY • MARCH 31 • 1978 • 5:18P.M.
THIS BOX HAS NO BRAND NAME ON
IT BECAUSE THERE IS NO WAY TO
DESCRIBE THE CONTENTS • • • BUT
THE DOG NOSE

Collection: Mr. & Mrs. Richard Roeder, Houston, Texas

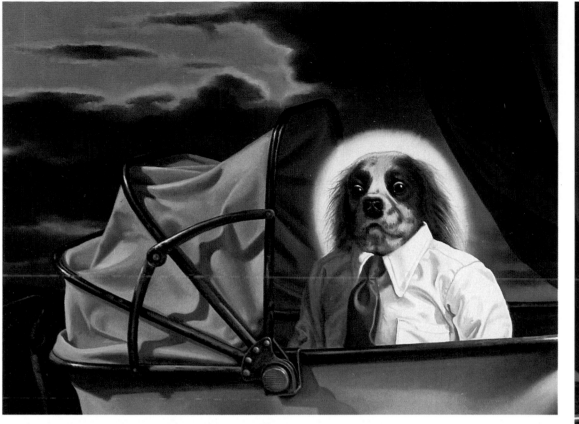

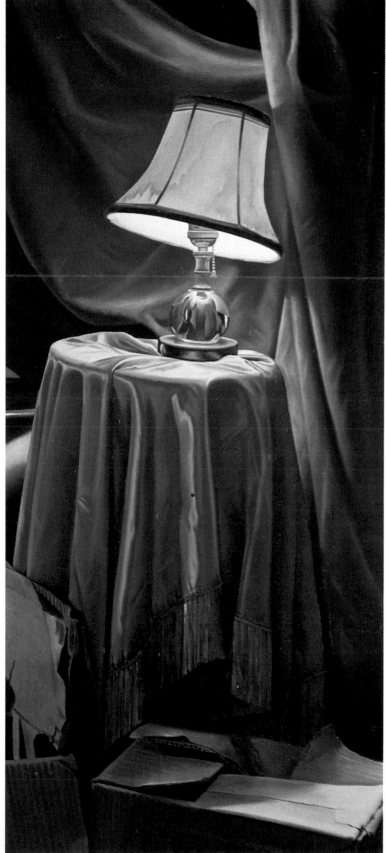

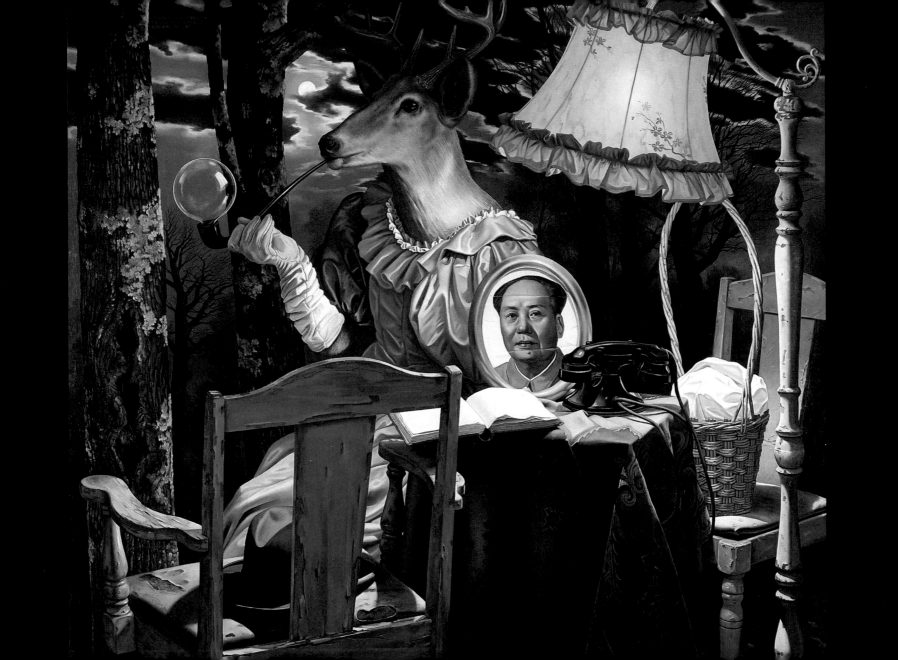

IN THE EVENING—WAITING
FOR A CALL WHICH SURELY CAME
AND WAITING FOR THE NEWS WHICH CAME BEFORE THE CALL,
WE HID OUT AS A WELL-DRESSED DEER
WHILE BUBBLES IN THE PARK
BEGAN TO DRIFT
AND SHRINK
AND BURST—BEFORE THE FALL

Oil on canvas
42 x 48 inches
Signed, upper left:
DONALD ROLLER WILSON
FRIDAY • FEBRUARY 10
6:08P.M. 1978 ♥

Collection: Private

DON'S NIGHT FLIGHT OVER SHIRLEY'S TINY HOME
IN THE FIELD OR STATIC NEAR THE SOLE

SOME DID THINK THAT DON WENT DOWN
AND SOME THOUGHT HE WENT UP
AND SOME HAD SEEN A RED LIGHT NEAR HIS SOLE

SOMEONE SAID HE HAD JUST ONE
BUT ONE KNEW HE HAD TO;
AND SOME HAD SEEN THE SPACE AROUND HIS WHOLE

BUT WHAT MOST DIDN'T KNOW AT ALL
WAS HE WENT UP AND DOWN
AND ALL THAT HEAT JUST REALLY LEFT HIM OLD

SO, DON WENT UP IN SMOKE LAST NIGHT
(THOUGH SOME THOUGHT HE WENT DOWN)
AND NONE HAD SEEN HIM THROUGH THE GLORY HOLE

Oil on canvas (top panel, oil on masonite and neon)
55 x 51 inches (unframed)
67 x 60½ inches (framed)
(Painting in frame designed by the artist, frame intended as part of the art)
Signed, lower right:
DONALD ROLLER WILSON • 1981/76
5:43P.M. THURSDAY • AUGUST 13
NOW TO SHOW THE SLIM RABBIT WHO WAITS
PLUS, OFF SOON TO MELANIE CAT'S WEDDING!

Collection: Private

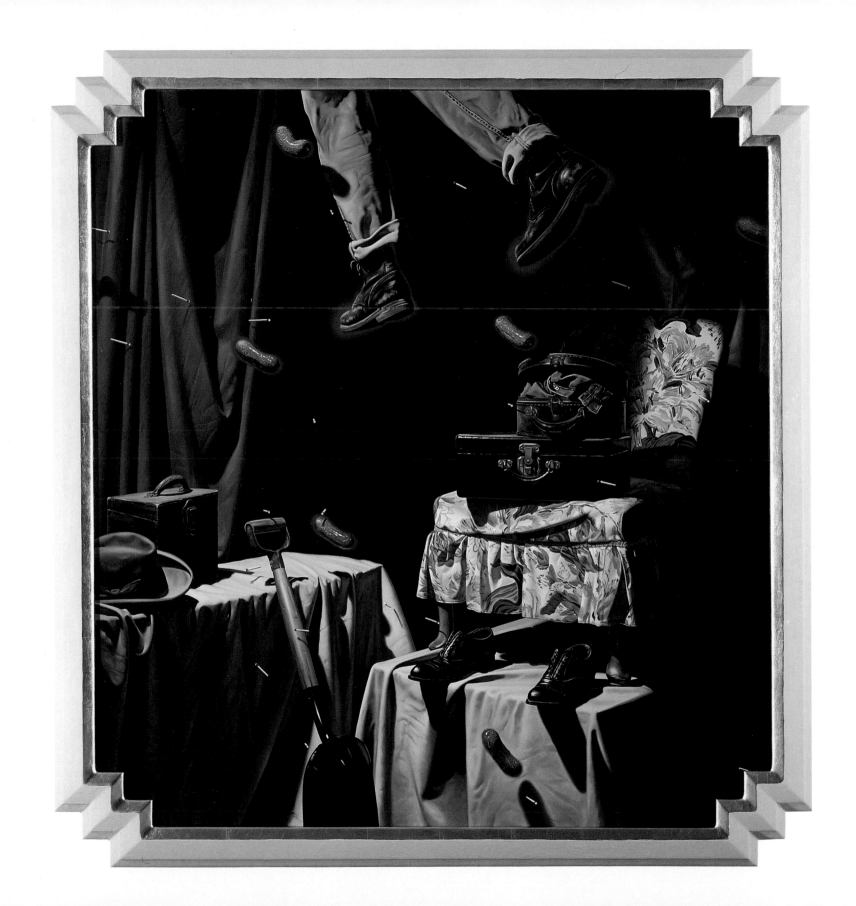

61

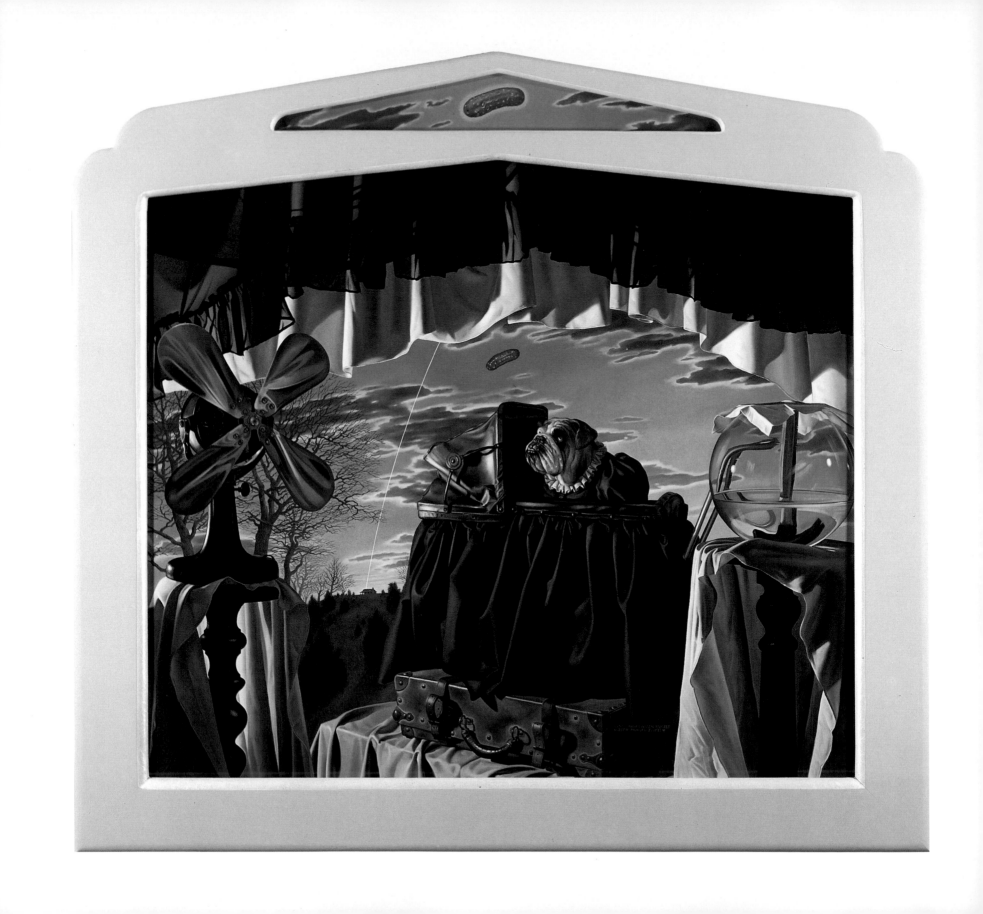

◄ THE ARRIVAL OF HELEN (SISTER OF LARRY) IN THE FIELD
SURROUNDING SHIRLEY'S SMALL HOME

SHIRLEY WAITED IN HER HOME;
TWO ARKS ARCHED OVERHEAD
GREEN, AND WHITE (THEIR COURSES NEVER MET)

THOUGH THE WHITE ONE WAS TOO HIGH
THE GREEN ONE WAS JUST RIGHT
AND HELEN SAW IT (FROM HER BASSINET)

Oil on canvas (panel in frame, oil on masonite)
42 x 48 inches (unframed)
53½ x 57½ (framed)
(Painting in frame designed by artist; frame intended as part of the art)
Signed, lower center right:
DONALD ROLLER WILSON • 1980/55
6:38P.M. MONDAY • JULY 21

Collection: Private

JANE'S FRIEND JUDEE'S BIG WASHINGTON TRIP WHERE ►
SHE WAS FOLLOWED BY LYLE METSDORF'S LONG AND
POINTED AIR-BORNE YELLOW ROBOT EBERHARD-FABER

Oil on canvas
26 x 22 inches (unframed)
41½ x 32 inches (framed)
(Painting in frame designed by artist; frame intended as part of the art)
Signed, lower panel, upper center:
JANE'S FRIEND JUDEE (WIFE OF MR. MONICALBERGER)
SNEAKED THROUGH THE HALL OF LINCOLN'S MEMORIAL
ON HER WAY TO WASHINGTON. SHE HAD BEEN CALLED
TO COME ONCE BEFORE, BUT HAD NOT. NIXON HAD BEEN
IN OFFICE AND SHE FOUND HIS LIPS TOO THIN, SO SHE HELD ON,
SHE STAYED HOME. BUT SHE WAS COMING NOW. AND SHE
WOULD TRY TO ARRANGE TO KISS PRESIDENT REAGAN ON
THE LIPS. SHE LIKED HIS LIPS. THEY WERE GOOD-LOOKING
TO HER. SHE HAD COME QUICKLY AND THE TRIP WAS LIKE A
PARADE SHE WAS IN. FIRST THERE WAS HER SHADOW,
THEN HER, THEN HER PENCIL, AND THEN A WIENIE AND
A CAULKING GUN TUBE. THEY WERE IN A ROW AND
THEY WERE COMING FAST • DONALD ROLLER WILSON • 3:05P.M.
1982/46 WEDNESDAY • SEPTEMBER 29 • CARRIE CAME TODAY
TOO • THE ROBOT PRINCESS • SHE WORE HER WITCH HAT
AND SOME BEAT-UP OLD BLUE SHOES ♥

Collection: HMC

63

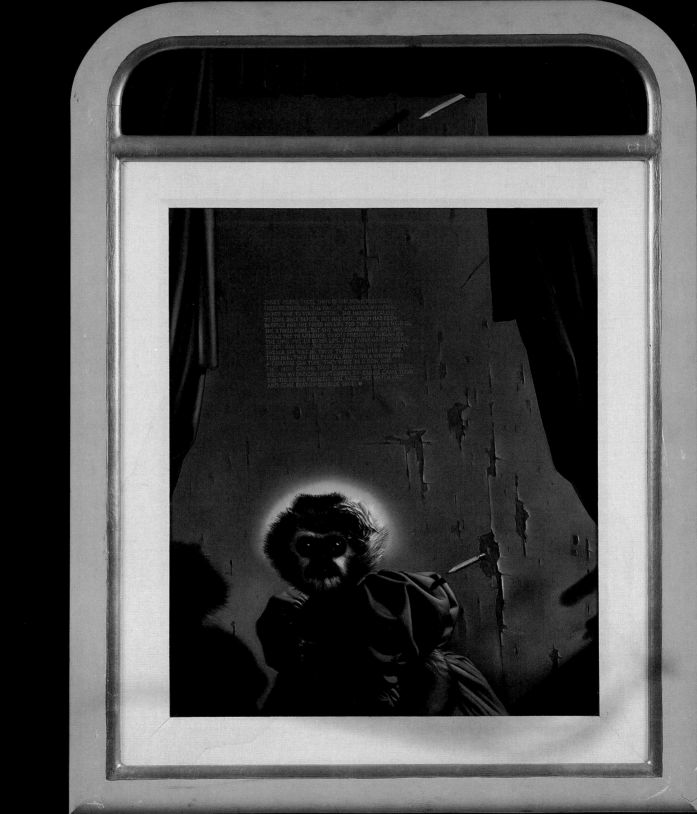

64

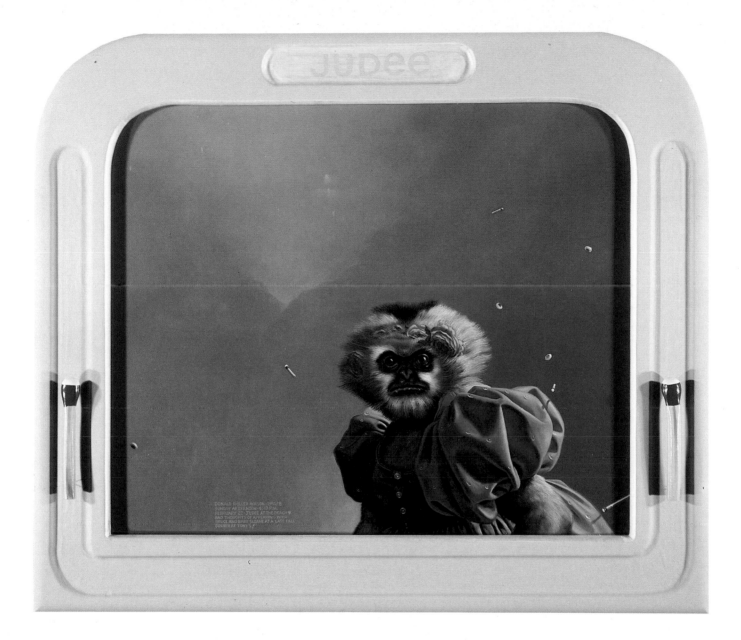

THE EMERGENCE OF JUDEE: FRIEND OF BRUCE: THOUGH BRUCE HAS
NOT SHOWN UP YET

JUDEE CAME AROUND TODAY; JUST CAME RIGHT INTO VIEW;
SHE WANDERED ON THE BEACH TO LOOK FOR BRUCE
BLACKEYED PEAS FLEW OVERHEAD (ESCAPEES FROM A STEW)
THAT JUDEE WARMED WITH MATCHES—HOT, THOUGH WET WITH JUICE

THE WET ONES SOMETIMES WOULDN'T LIGHT; SHE HAD STRUCK A FEW
SHE LOOKED OUT ON THE BEACH WHERE SHE SAW BRUCE
BLACKEYED PEAS WERE ROUND HIM TOO (ESCAPEES FROM THE DEW)
THAT JUDEE WARMED WITH MATCHES—WET, THOUGH HOT FROM JUICE

Oil on canvas
25 x 30 inches (unframed)
33 x 38 inches (framed)

(Painting in frame designed by artist; frame intended as part of the art)
Printed, top of frame:
JUDEE
Signed, lower left:
DONALD ROLLER WILSON • 1981/8
SUNDAY AFTERNOON • 4:47P.M.
FEBRUARY 22 • JUDEE AT THE BEACH ♥
AND THOUGHTS OF APPEARING WITH
BRUCE AND BABY SLOANE AT A LATE FALL
DINNER AT TONY'S!

Collection: Dr. & Mrs. Sidney Anderson, Houston, Texas

65

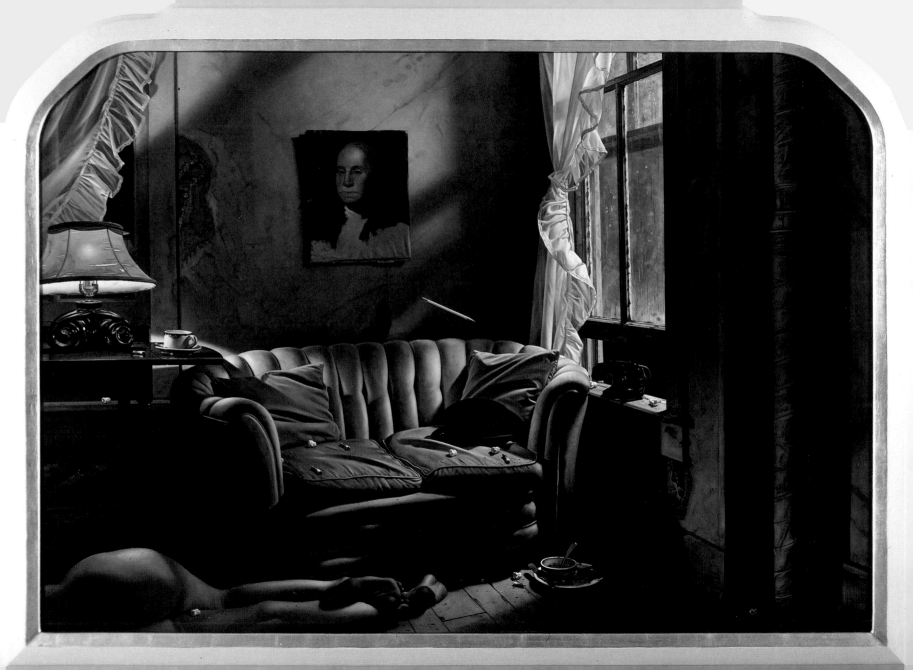

PASSOVER: THE WRITING ON THE WALL: DAWN'S SHORT NAP

DON'S PENCIL HEADED FOR THE WALL
TO LIST THE NUMEROUS COLONELS
HIS SISTER POPPED BEFORE SHE WENT TO BED

AND WHEN HIS NEIGHBORS FOUND THE SCORE
(THE WRITING ON THE WALL)
THEY SAW HER THERE AND THOUGHT SHE MUST BE DEAD

THEY SAW HER CUP AND DISH OF BEANS
UNTOUCHED, DOWN ON THE FLOOR
THE FILTERS OF HER STUBS WERE STAINED DARK RED

THEY DIDN'T KNOW WHERE DON HAD GONE
(SOMETIMES, HE'D DISAPPEAR
BENEATH THE HAT HE KEPT UPON HIS HEAD)

Oil on canvas
50 x 72 inches
Signed, lower left:
DONALD ROLLER WILSON • 1982/16
9:30P.M. TUESDAY EVENING • MAY 4
P/12:55P.M. 6/11/82

Collection: Private

MRS. JENKINS' LATE-NIGHT DINNER IN HER ROOM, ALONE

(WHILE, OUT IN THE HALL LEADING <u>TO</u> HER ROOM, HER SMALL
FRIENDS WERE SLEEPING)

MRS. JENKINS SET HER TABLE
MADE IT LOOK LIKE TWO
HAD DINED TOGETHER IN HER ROOM LAST NIGHT

AND IN THE MORNING—THROUGH HER KEYHOLE
MOST WHO PEEKED INSIDE
HAD SEEN THE PLATES BUT <u>NONE</u> HAD SEEN THE LIGHT

AND <u>VERY</u> FEW WHO SAW CAUGHT ON
FOR MOST WERE FOOLED—IT SEEMED
AND THOSE WHO <u>KNEW</u> HAD TRIED TO BE POLITE

THEY KNEW THAT THOUGH SHE PLAYED HER TRICKS
DOWN DEEP, SHE WAS INSIDE
AND, IN THE END, THAT SHE WOULD BE ALLRIGHT

Oil on canvas
50 x 72 inches (unframed)
56 x 78 inches (framed)
(Painted in frame designed by artist; frame intended as part of the art)
Signed, lower left:
DONALD ROLLER WILSON • 1984/12-A
6:32P.M. SATURDAY EVENING • JULY 14

Collection: Archer M. Huntington Gallery,
University of Texas at Austin, Texas

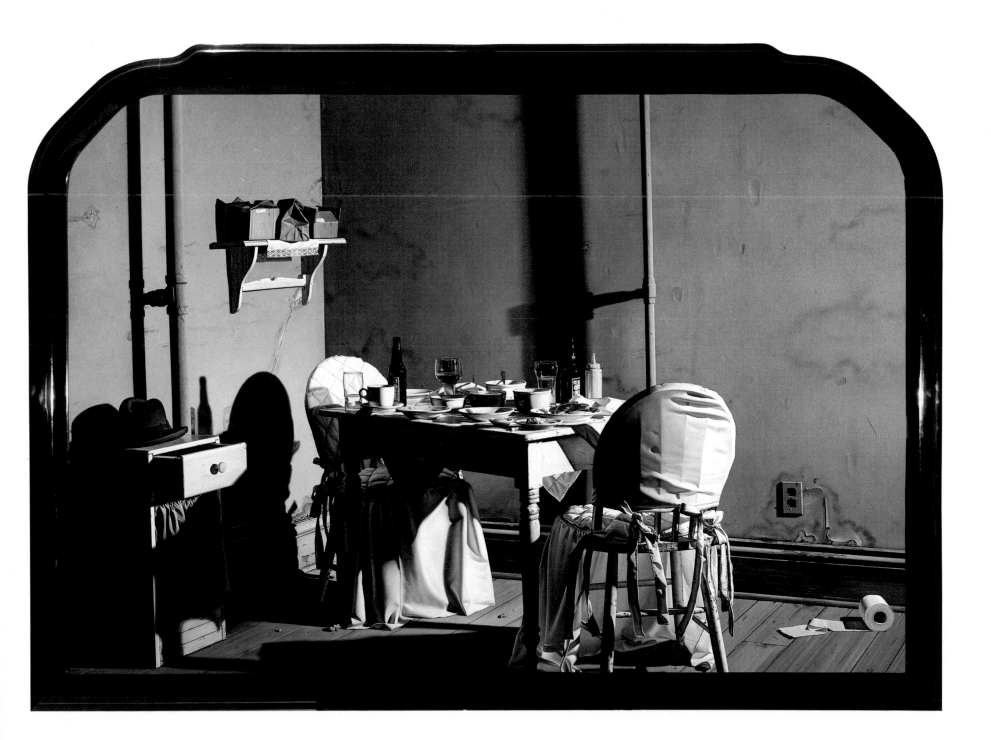

PASSOVER: THE WRITING ON THE WALL

AT DINNER WITH THE HOLY GHOST,
DON'S PLACE WAS ON THE LEFT
AND HAD BEEN SET WITHOUT A KNIFE OR FORK AND SPOON

BUT ON THE RIGHT, THE HOLY GHOST
SAT NAKED IN HER CHAIR
AND ATE HER TOAST AND SMOKED AND, LATER, LEFT THE ROOM

SHE'D TAKEN DON; AN AIR-BORNE PATH
HAD MARKED THE COURSE THEY TOOK
AN ARC (A THIN CURVED PATH OF DARK MAROON)

IT WHIZZED IN CIRCLES THROUGH THE NIGHT
ABOVE THE MESS THEY LEFT
ABOVE THE TABLE IN THE DINING ROOM

Oil on canvas (triptych comprised of five canvases)
Center canvas: 60 x 36 inches (unframed)
Upper canvases, right/left: 8 3/8 x 13 3/4 inches, each (unframed)
Lower canvases, right/left: 40½ x 13¾ inches, each (unframed)
Painting overall: 66¾ x 79 inches (framed)
(Painting in frame designed by artist; frame intended as part of the art)
Signed, lower right, lower right canvas:
DONALD ROLLER WILSON • 1982/32
6'123P.M. FRIDAY EVENING • JULY 9

Collection: Private

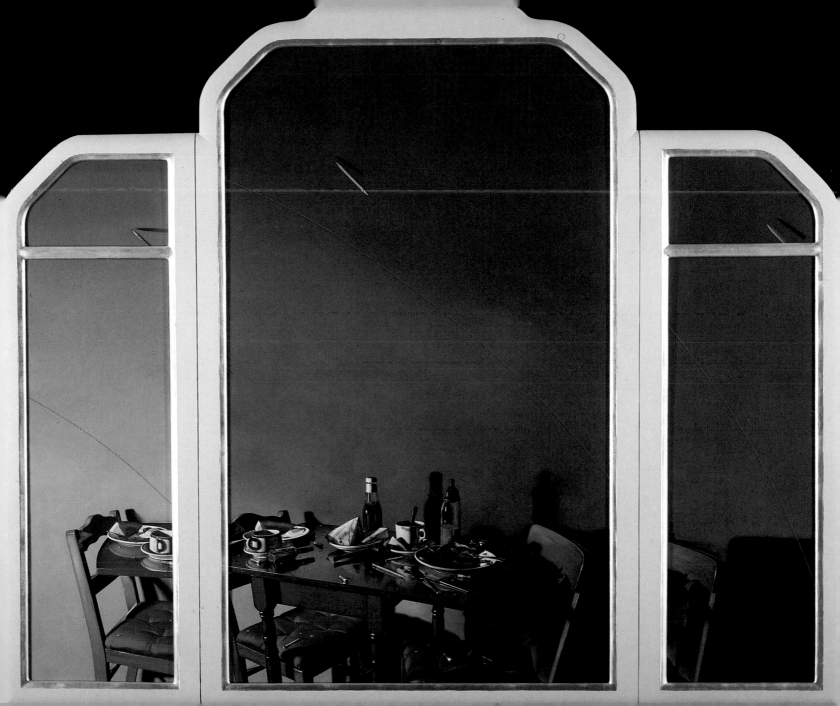

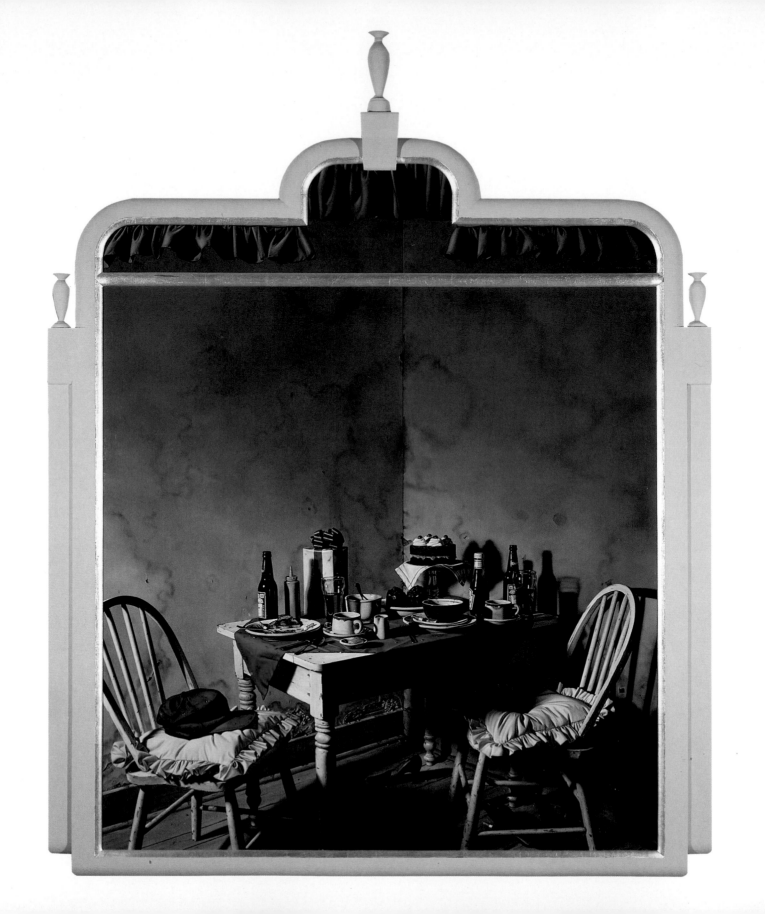

CARRIE'S AND DON'S UNCLE EZRA'S BIRTHDAY DINNER AT DON'S

CARRIE'S SHOES AND EZRA'S CAP HAD HAD A FILLING MEAL
THOUGH EITHER OWNER'S BODY HAD NOT BEEN THERE
WHEN EZRA'S CAP HAD HAD ENOUGH, IT RESTED ON THE CHAIR
AND CHANGED FROM GREEN TO PALE GREEN AS IT LAID THERE

WHEN CARRIE'S SHOES HAD HAD THEIR FILL, THEY SPRAWLED OUT ON THE FLOOR
A DIFFERENT BLUE THEY'D BEEN THE NIGHT THEY DINED THERE
THE JAM GOT THICK BUT STAYED REAL RED AND THE BEER TURNED DARKER YELLOW
AND THE GIFT (WRAPPED IN ITS BOX) JUST SHRIVELED UP THERE

SO, EACH THING CHANGED IN ITS OWN WAY (AND SOON WOULD DISAPPEAR)
BUT NOTHING MOVED, FOR STILLNESS MADE ITS PLACE THERE

Oil on canvas (bottom panel); oil on masonite (top panel)
Bottom panel: 50½ x 50 inches (unframed)
Top panel: 10½ x 4½ inches (unframed)
Painting overall: 76¼ x 59½ inches (framed)
Signed, top panel:
DRW • 9:52P.M. 5/7/83
Signed, bottom panel, lower right:
DONALD ROLLER WILSON • 1983/7
12:23P.M. SUNDAY • MAY EIGHTH
MOTHER'S DAY • FOR MOTHER AND
UNCLE EZRA IN STILLWATER ♥

Collection: Mr. & Mrs. Thomas K. Ireland

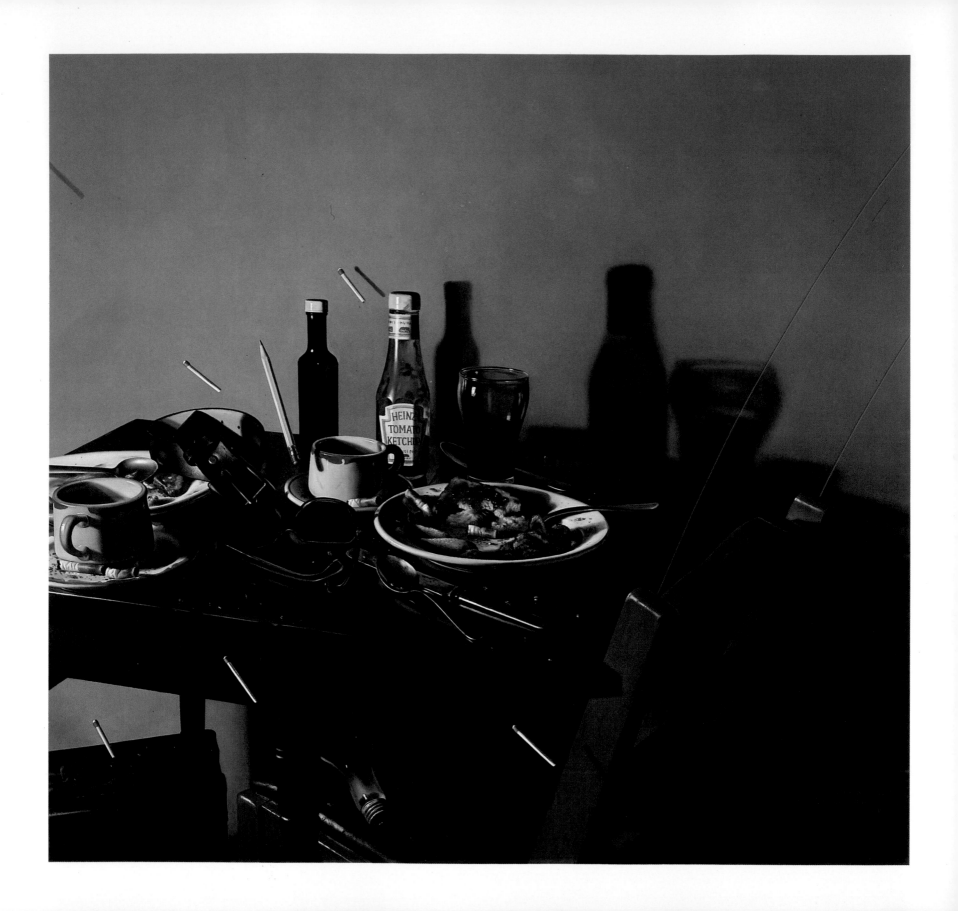

◄ PASSOVER: ONE OF DON'S LAST EVENINGS WITH MYSTERY

THE CHAIR WHERE MRS. MYSTERY SAT
BEGAN TO SPARK AND SEND OFF LIGHT
THE PLACE WHERE SHE HAD BEEN WOULD SOON BE GONE

THE PENCIL HEADED FOR THE WALL
TO MARK THE PATH SHE'D MADE THAT NIGHT
TO WRITE THE MANY PLACES SHE'D GONE WRONG

AND IN THE MORNING DON RETURNED
TO READ THE WRITING ON THE WALL
SO HE WOULD KNOW WHERE SHE HAD BEEN SO LONG

BUT THE MESSAGE THERE HAD BEEN IN TONGUES
AND DON JUST COULDN'T UNDERSTAND
AND THE CHAIR ON WHICH SHE DINED WITH HIM—WAS GONE

Oil on canvas
28 x 30 inches
Signed, lower right:
DONALD ROLLER WILSON • 1982/9
CLOSE TO 6:00P.M. FRIDAY
FEBRUARY 19 • SO TO SPEAK ♥

Collection: Candy Clark, Los Angeles, California

THE NIGHT BEFORE THE SCHEDULED BIRTH OF DON'S SISTER, ►
PATRICIA, WHO WE HAVE SEEN OTHER THAN AS THE DOG
SHE USED TO BE (LIVING WITH MONTE AND DICK IN HOUSTON)

MRS. MYSTERY'S DAUGHTER'S SHOES
WERE SMOKING LATE LAST NIGHT
(SOME TOELESS PLATFORM SLINGBACKS WITHOUT TONGUES)

WHEN MORNING CAME, PATRICIA AWOKE
AND KNEW SHE COULDN'T WEAR THEM
(FROM ALL THE HEAT, THEY'D BURN THE LADDER'S RUNGS)

SO, SHE HELD STILL—SHE DIDN'T CLIMB
AND MRS. MYSTERY WAITED
(SHE HELD THE BREATH WHICH STRAINED INSIDE HER LUNGS)

MRS. MYSTERY'S DAUGHTER'S SHOES
WENT UP IN SMOKE LAST NIGHT
(SOME SOULLESS PLATFORM SLINGBACKS WITHOUT TONGUES)

Oil on canvas
20 x 16 inches
Signed, lower right:
DONALD ROLLER WILSON • 1982/8
6:43P.M. WEDNESDAY • FEBRUARY 17

Collection: Bill & Sandra Tranum

75

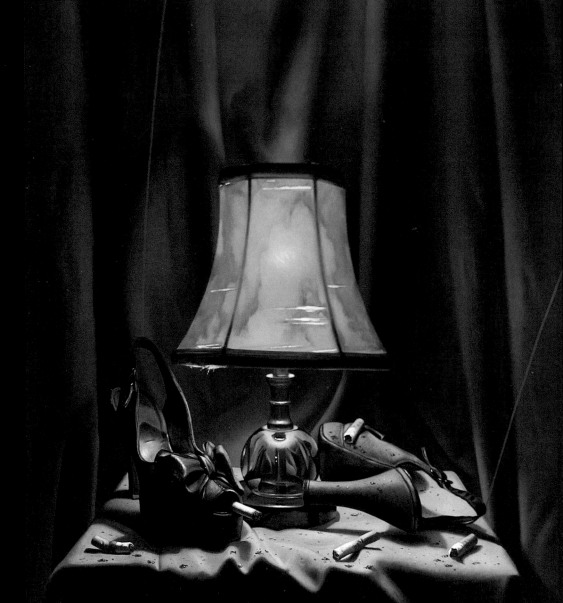

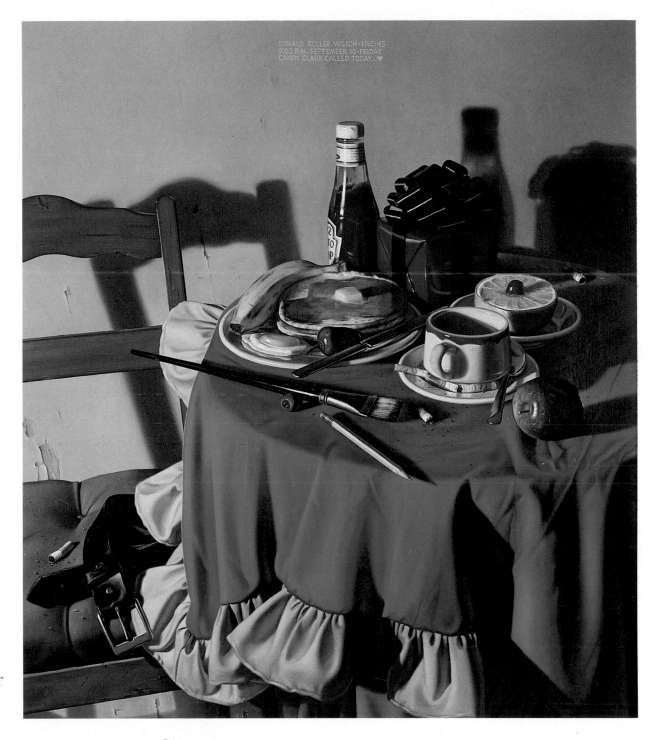

▶

A PINK CHAIR WITH A BLACK MANS BELT
BESIDE
A SMALL TABLE WITH A BLUE CLOTH
WITH A YELLOW RUFFLE
AND
SOME CATSUP AND PANCAKES AND A BANANA AND
A HOT PEPPER AND AN EGG WITH SOME PEPPER
ON IT
AND SOME COFFEE A BRUSH WITH MORE BUTTS
AND A HALF OF A GRAPEFRUIT IN A BOWL WITH A
CHERRY
AND AN APPLE A SPOON A KNIFE AND A GIFT WRAPPED UP IN
RED

Oil on canvas
25 x 22 inches
Signed, upper center:
DONALD ROLLER WILSON • 1982/45
9:03P.M. SEPTEMBER 10 • FRIDAY
CANDY CLARK CALLED TODAY… ♥

Collection: Mildred Pattin, Houston, Texas

77

THE LATE-NIGHT DISAPPEARANCE OF MRS. LAMAR JENKINS AS SHE
WAS SUCKED DOWN (AND THROUGH) THE CUSHION ON HER CHAIR WHERE
SHE HAD BEEN SIMULTANEOUSLY EATING HER DINNER AND READING

MRS. JENKINS FOUND A BOOK (SHE JUDGED IT BY ITS COVER)
THE TITLE AND THE TEXT HAD BEEN REVERSED
SHE STRUGGLED THROUGH THE WORDS WHILE FEELING CERTAIN THEY WERE GREEK
AN ANCIENT TREATISE ON THE UNIVERSE

SHE VAGUELY FELT THE WORDS SHE READ WERE FORECASTS OF WARPED SPACE
A BLACK-HOLE THEORY WRITTEN IN GREEK VERSE
AND THE MORE SHE READ, THE MORE SHE ATE, AND AS HER WEIGHT INCREASED
SHE SANK AND—BY HER CUSHION—WAS IMMERSED

Oil on canvas
36 x 50 inches
Signed, lower center, left:
DONALD ROLLER WILSON • 1983/21
THURSDAY EVENING • AUGUST 4 • ♥
6:52P.M. THEN (W.O.B.) • 11:56A.M.
8/5/83 • (L.O.C.) • 3:38P.M. 8/5/83

Collection: Mr. & Mrs. Thomas K. Ireland

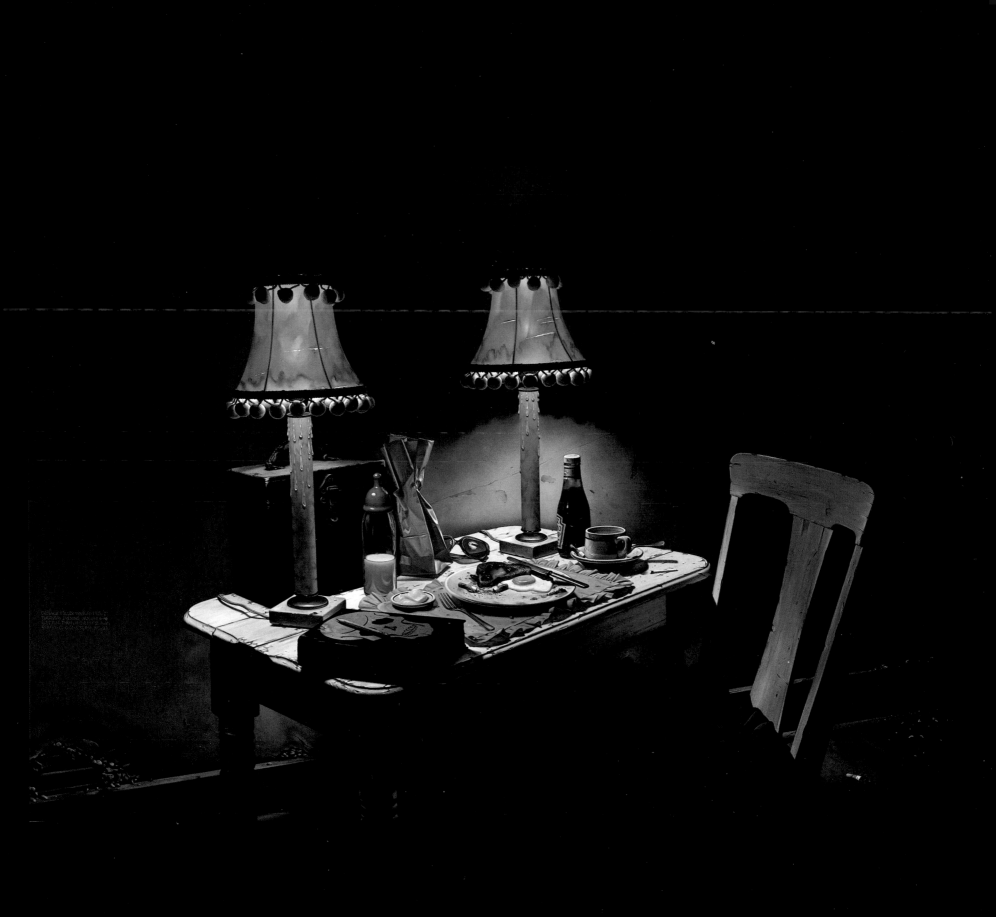

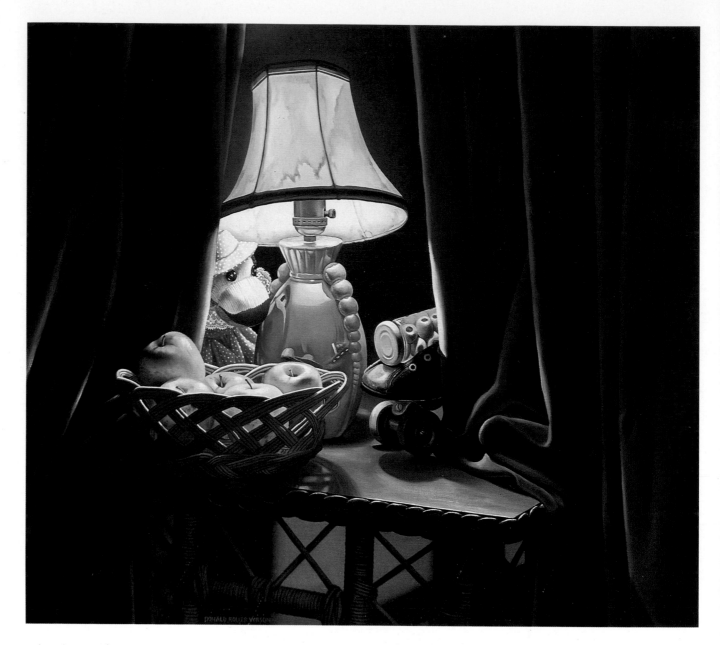

SHIRLEY WATCHES AS SOME RIDERS ▲
RIDE IN ON A ROLLER SKATE;
SOME MAY THINK THEY COME FROM STORES
BUT SHIRLEY KNOWS ABOUT THE GATE

Oil on canvas
24 x 26 inches
Signed, bottom left center:
DONALD ROLLER WILSON

Collection: Private

SHIRLEY SAW HER FACE LAST NIGHT REFLECTED IN HER LAMP ▶
A HEART-SHAPED DEENA LAMP DESIGNED BY BRUCE
AND THOUGH SHE HAD REMOVED THE BULB, THE LAMP BURNED ON AND ON
A MYSTERY LIGHT WHOSE SOURCE SHE DID DEDUCE
HAD COME FROM CHAIRMAN HAROLD FROM THE FACTORY IN KENTUCKY
WHO SENT THE BEAMS FROM HEAVEN DOWN HER WAY
THEY SHONE UPON HER EVENING MEAL AND LIGHTED UP HER WRIST
WHERE SHE WORE THE COMPANY TAG BOTH NIGHT AND DAY

Oil on canvas
20 x 24 inches

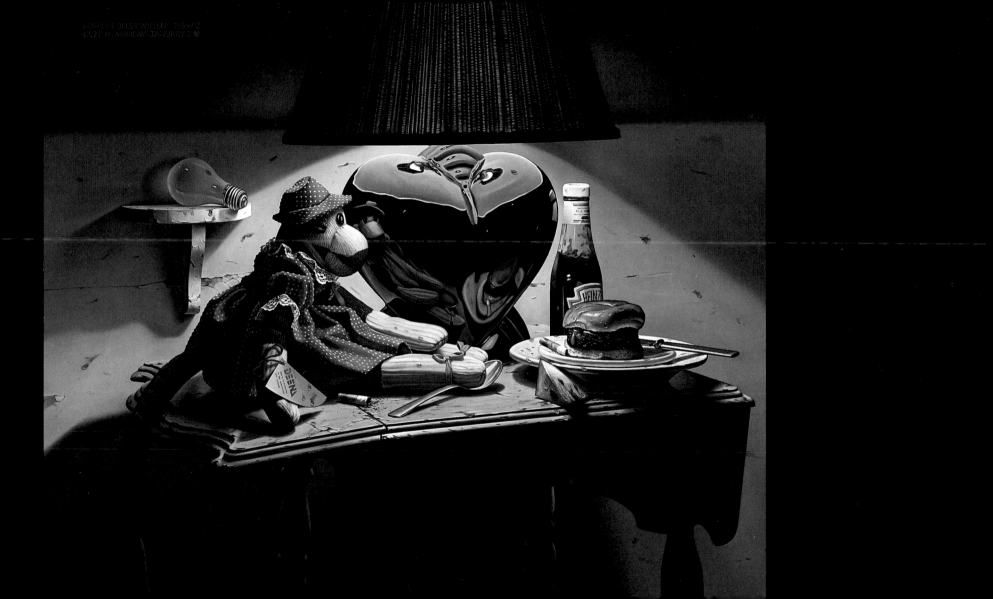

JIMMY STOOD IN THE HALLWAY FOLLOWING THE HIGH WINDS
WHICH WHIPPED UP A LOT OF ITEMS FROM MRS. JENKINS'
KITCHEN WHERE SHE HAD BEEN FIXING A LATE-NIGHT
SNACK FOR HELEN (ALONE) WHO HAD COME HOME LATE
FROM THE MISS DOG AMERICA CONTEST (WHICH SHE HAD WON)

Oil on panel (linen over masonite)
23½ x 31 inches (unframed)
28½ x 35 inches (framed)
Painting in frame designed by the artist; hand-carved frame
intended as part of the art)
Signed, lower left, under chair rail on wall of painting:
DONALD ROLLER WILSON • 1987/31 • 6:17P.M.
♥ FRIDAY EVENING • JUNE 19 • JIMMY…

Collection: Private

balls of fire

KATHLEEN'S AND SHIRLEY'S FRIEND WAITED IN THE HALL
BY THE DOOR LEADING TO MRS. LAMAR JENKINS' ROOM

Oil on linen panel (panel attached to masonite)
24 x 31 inches
(Painting in frame designed by the artist, frame intended as part of the art)
Signed, upper right:
balls of fire
Signed, center left:
HE HEARD ABOUT THEM FROM KATHLEEN AND
SHIRLEY BUT MAINLY SHIRLEY AND SHE TOLD HIM
SHE HAD SEEN ONE IN THE HALL OUTSIDE THE
DOOR GOING TO MRS. JENKINS' ROOM AND FROM
THE WAY SHE SAID IT HE WASN'T SURE IT
WAS GOING TO HER ROOM OR THE DOOR WAS
GOING TO HER ROOM SO HE WENT TO THE
SAME PLACE BOTH GIRLS SAID THEY HAD SEEN
IT AND WAITED

Signed, center right, line for line:
AND WHILE HE WAITED HE WORRIED THAT
THE UPPER PARTS OF HIS BODY WERE BARE
BECAUSE SHIRLEY HAD IMPLIED THEY WERE
LOVE OBJECTS HAVING TO WITH REPRODUCTION
(THOUGH NOT IN THOSE WORDS) BUT KATHLEEN SAID
THEY WERE MORE LIKE SLOWLY MOVING SPHERES
OF LIGHT BUT AT ANY RATE HE DIDN'T WANT
TO WIND UP BEING LIKE THE GIRL MRS. JENKINS
CAUGHT STANDING OUTSIDE HER ROOM WITH NO
BRASSIERE • 4:59PM. SUNDAY • APRIL 9 • 1984/7
DONALD ROLLER WILSON

Collection: The Chase Manhattan Bank

83

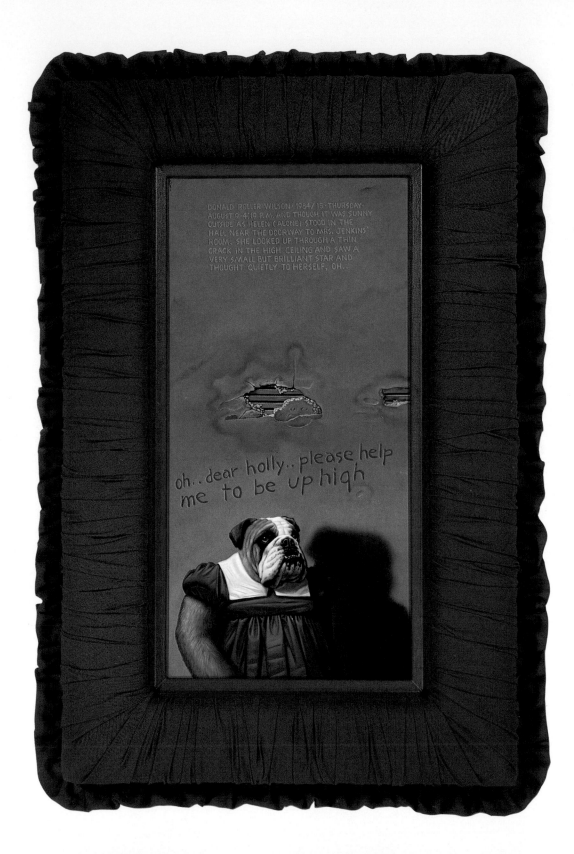

HELEN'S PRAYER TO HOLLY TO BE A PIE
(EXCEPT, HER THOUGHTS WERE MISSPELLED
 AND SHE WOUND UP
ON THE ROOF OF MRS. JENKINS' HOUSE)

Oil on canvas
18 x 9 inches (unframed)
24 x 15 inches (framed)
(Painting in frame designed by artist; frame intended as part of the art)
Signed, upper center:
DONALD ROLLER WILSON • 1984/15 • THURSDAY •
AUGUST 9 • 4:19P,M, AND THOUGH IT WAS SUNNY
OUTSIDE AS HELEN (ALONE) STOOD IN THE
HALL NEAR THE DOORWAY TO MRS. JENKINS'
ROOM, SHE LOOKED UP THROUGH A THIN
CRACK IN THE HIGH CEILING AND SAW A
VERY SMALL BUT BRILLIANT STAR AND
THOUGHT QUIETLY TO HERSELF, OH..
Signed, lower center in red letters:
oh...dear holly...please help
me to be up high

Collection: Private

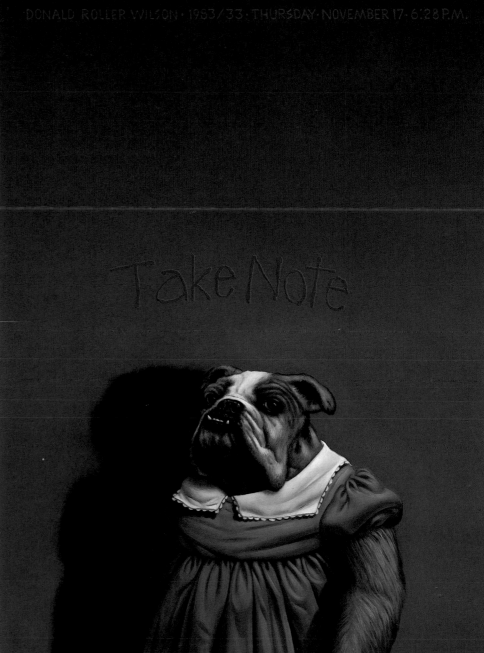

KATHLEEN'S AND SHIRLEY'S FRIEND STOOD IN MRS. JENKINS' ROOM

Oil on canvas
12 x 9 inches
Signed, upper center:
DONALD ROLLER WILSON • 1983/33 • THURSDAY • NOVEMBER 17 • 6:28P.M.
Signed, center, above figure, in cadmium red letters:
Take Note

Collection: Private

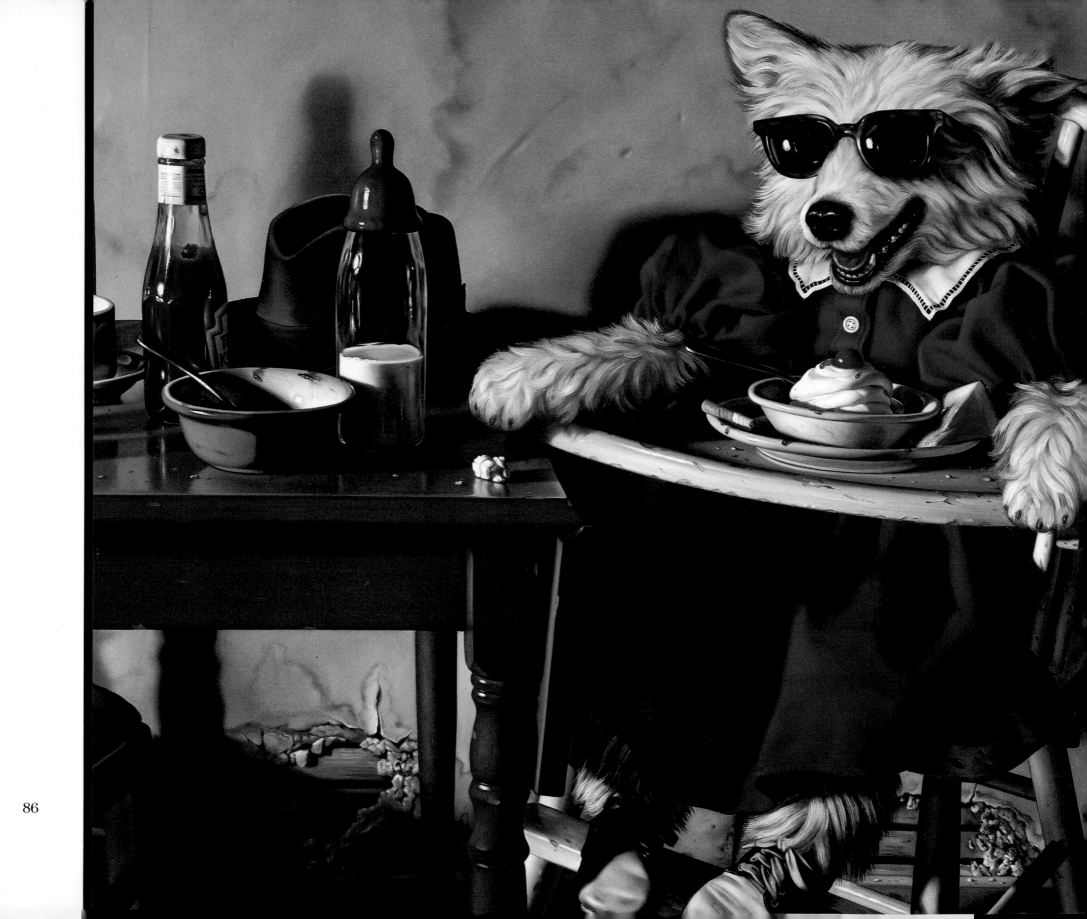

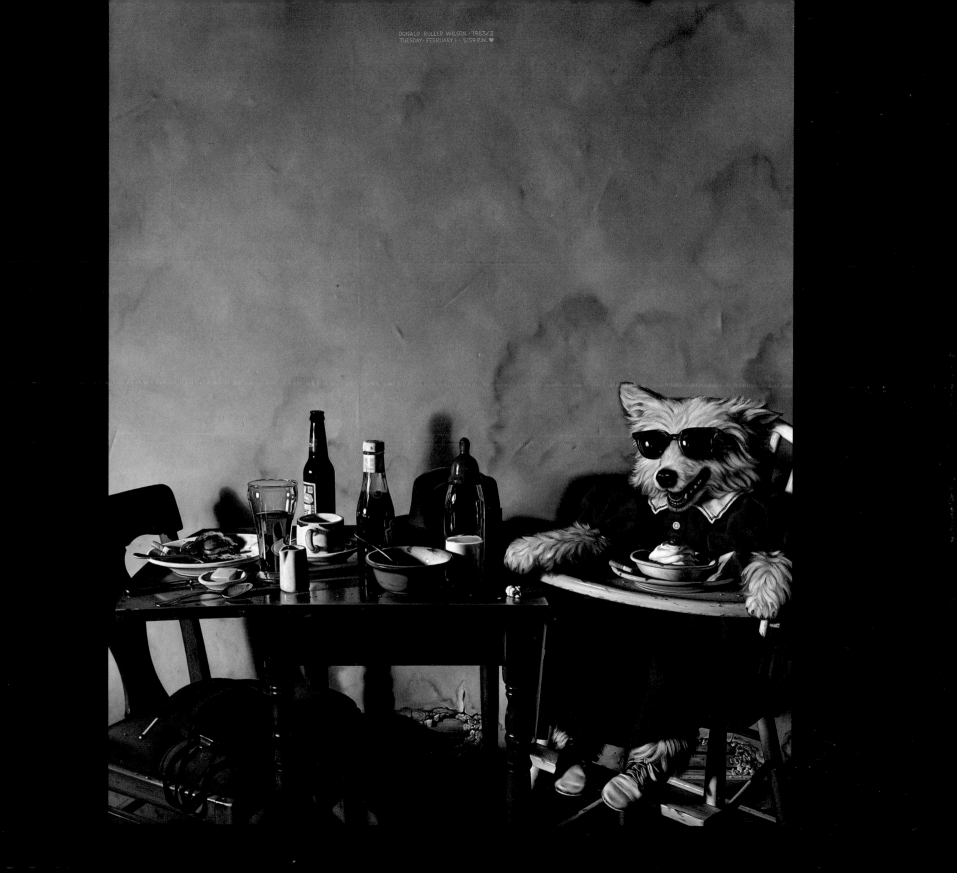

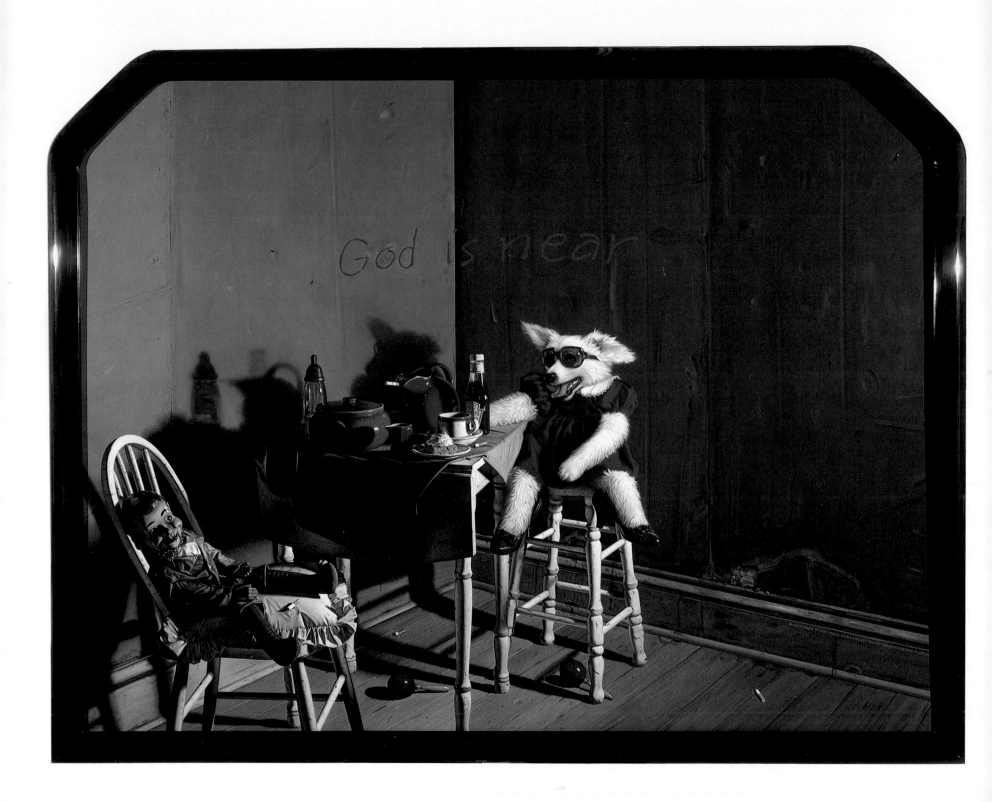

◄ MRS. JENKINS HAD TURNED HER OLD PINK BEDROOM INTO
A DINING ROOM FOR HER DOG, PATRICIA

PATRICIA DIDN'T WANT HER FRIEND
TO SEE HER EAT HER MEAL
HIS GAZE WAS FIXED (HE WOULDN'T LOOK AWAY)

SHE PRAYED HE'D BLINK (SHE'D SNEAK A BITE)
AND SWALLOW FAST SHE COULD
HIS GAZE WAS FIXED (HE COULDN'T LOOK AWAY)

SO BOTH SAT TIGHT FOR YEARS AND YEARS
PATRICIA PRAYED TO SLEEP
HE COULDN'T SLEEP (HIS GAZE WAS THERE TO STAY)

BUT GOD WAS NEAR AND HEARD HER PRAYER
AND CAME INTO THE ROOM
AND MADE HER FRIEND WATCH THE T.V.
SO PATRICIA COULD FINISH HER DINNER AND
PATRICIA WAS REALLY GLAD BECAUSE SHE HAD
WAITED SO SO LONG

Oil on canvas
50 x 65 inches
Signed, lower right, along baseboard, on one line:
♥ SEPTEMBER 17 • FULL MOON • DONALD ROLLER
WILSON • 1986/17 • WEDNESDAY • 7:00P.M.

Collection: Peter & Alison Baumann

MRS. JUDD SEEN COMING OUT OF THE BATHROOM AT HOLLY'S IN ►
NEW YORK WHERE, LATER, SHE WAS ASKED TO LEAVE (BUT SHE
BOUGHT SOMETHING AND HOLLY DECIDED TO LET HER STAY)

Oil on canvas
29 x 24 inches
Signed, upper center, line for line:
MRS. JUDD (713) 622-2248 STUCK HER TONGUE OUT AT MRS. MONICAL (713) 522-9146 DURING
AN IMPORTANT ART SHOWING AT THE HOLLY SOLOMON GALLERY IN NEW YORK AND MRS.
SOLOMON (212) 757-7777 SAW HER DO IT AND NORMALLY WOULD HAVE JUST LOOKED THE
OTHER WAY BUT THIS LITTLE STUNT PLUS THE FACT THAT MRS. JUDD SHOWED UP NAKED
EXCEPT FOR HER WHITE HAT MADE MRS. SOLOMON HAVE TO LOCK UP BOTH MRS. JUDD
AND MRS. MONICAL IN THE BATHROOM FOR THE WHOLE EVENING (SHE THOUGHT) AND
PETER LINKER (UNLISTED) WHO IS A VERY IMPORTANT ART CRITIC IN NEW YORK SAW
THEM BEING LOCKED UP AND TOLD MRS. SOLOMON THAT SHE SHOULD LET BOTH
LADIES OUT BECAUSE THEY WERE BOTH VERY RICH AND MIGHT BUY SOMETHING
BUT MRS. SOLOMON TOLD PETER IF HE DIDN'T JUST KEEP HIS SUGGESTIONS IN HIS
COLUMN AND LIMIT HIS CRITICISM TO ART HE MIGHT WIND UP IN THERE WITH
THEM AND MRS. MONICAL HEARD THE THREAT THROUGH THE KEYHOLE AND
STARTED HAVING A LOUD FIT AND YELLING UNDER THE DOOR AT MRS. SOLOMON TO
PUT PETER IN THERE WITH HER AND MRS. JUDD BUT MRS. JUDD YELLED OUT THAT
SHE DIDN'T WANT PETER IN THERE AND THAT SHE WOULD PUT HER DRESS BACK
ON IF MRS. SOLOMON WOULD LET HER OUT SO MRS. SOLOMON LET MRS. JUDD
OUT AND PUT PETER IN THERE WITH MRS. MONICAL BUT AS SOON AS MRS.
JUDD GOT OUT SHE STUCK HER TONGUE OUT AT MRS. SOLOMON AND MRS.
SOLOMON DECIDED SHE HAD TO GET AWAY FROM MRS. JUDD SO SHE LET MRS.
MONICAL AND PETER OUT OF THE BATHROOM AND SHE WENT IN THERE HERSELF
AND LOCKED THE DOOR AND THE COLLECTORS THAT WANTED TO BUY WORKS
OF ART FROM THE SHOWING HAD TO STICK THEIR MONEY UNDER THE CRACK
OF THE DOOR TO MRS. SOLOMON ALL DURING THE EVENING AND SHE GOT
QUITE A LOT AND WHEN MRS. SOLOMON FINALLY CAME OUT ALL SHE COULD SAY
WAS...I...I'M SORRY, BUT, THEN...NOT...NOT TOO SORRY / DONALD ROLLER WILSON
1985/1 • 4:29P.M. JANUARY 5 • SATURDAY ♥

Collection: Private

93

MRS. JUDD (713) 522-2248 STUCK HER TONGUE OUT AT MRS. MONICAL (713) 522-9156 DURING
AN IMPORTANT ART SHOWING AT THE HOLLY SOLOMON GALLERY IN NEW YORK AND MRS.
SOLOMON (212) 757-7777 SAW HER DO IT AND NORMALLY WOULD HAVE JUST LOOKED THE
OTHER WAY BUT THIS LITTLE STUNT PLUS THE FACT THAT MRS. JUDD SHOWED UP NAKED
EXCEPT FOR HER WHITE HAT MADE MRS. SOLOMON HAVE TO LOCK UP BOTH MRS. JUDD
AND MRS. MONICAL IN THE BATHROOM FOR THE WHOLE EVENING (SHE THOUGHT) AND
PETER JUNKER (UNLISTED) WHO IS A VERY IMPORTANT ART CRITIC IN NEW YORK SAW
THEM BEING LOCKED UP AND TOLD MRS. SOLOMON THAT SHE SHOULD LET BOTH
LADIES OUT BECAUSE THEY WERE BOTH VERY RICH AND MIGHT BUY SOMETHING
BUT MRS. SOLOMON TOLD PETER IF HE DIDN'T JUST KEEP HIS SUGGESTIONS IN HIS
COLUMN AND LIMIT HIS CRITICISM TO ART HE MIGHT WIND UP IN THERE WITH
THEM AND MRS. MONICAL HEARD THE THREAT THROUGH THE KEYHOLE AND
STARTED HAVING A LOUD FIT AND YELLING UNDER THE DOOR AT MRS. SOLOMON TO
PUT PETER IN THERE WITH HER AND MRS. JUDD BUT MRS. JUDD YELLED OUT THAT
SHE DIDN'T WANT PETER IN THERE AND THAT SHE WOULD PUT HER DRESS BACK
ON IF MRS. SOLOMON WOULD LET HER OUT SO MRS. SOLOMON LET MRS. JUDD
OUT AND PUT PETER IN THERE WITH MRS. MONICAL BUT AS SOON AS MRS.
JUDD GOT OUT SHE STUCK HER TONGUE OUT AT MRS. SOLOMON AND MRS.
SOLOMON DECIDED SHE HAD TO GET AWAY FROM MRS. JUDD SO SHE LET MRS.
MONICAL AND PETER OUT OF THE BATHROOM AND SHE WENT IN THERE HERSELF
AND LOCKED THE DOOR AND THE COLLECTORS THAT WANTED TO BUY WORKS
OF ART FROM THE SHOWING HAD TO STICK THEIR MONEY UNDER THE CRACK
OF THE DOOR TO MRS. SOLOMON ALL DURING THE EVENING AND SHE GOT
QUITE A LOT AND WHEN MRS. SOLOMON FINALLY CAME OUT ALL SHE COULD SAY
WAS.. I.. I'M SORRY, BUT, THEN.. NOT.. NOT TOO SORRY / DONALD ROLLER WILSON
1985/1 · 4:29 P.M. JANUARY 5 · SATURDAY ♥

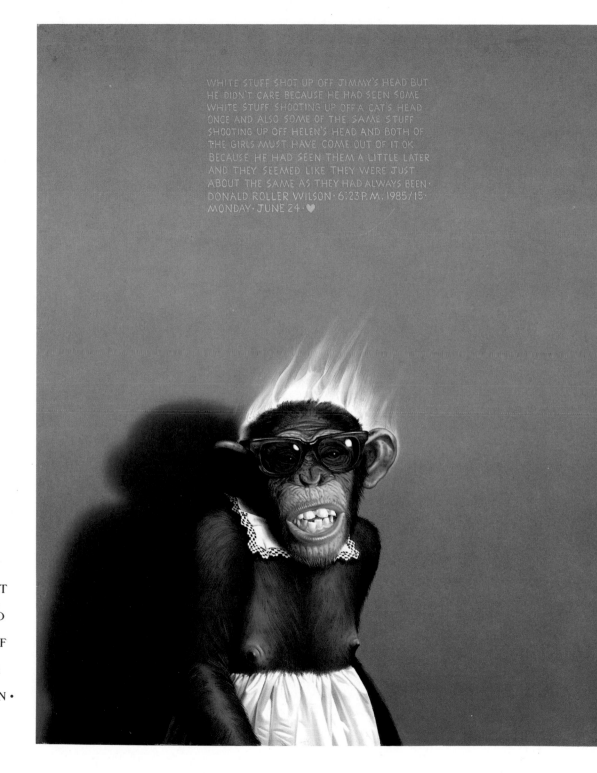

WHITE STUFF SHOT UP OFF JIMMY'S HEAD

Oil on canvas
20 x 16 inches
Signed, upper center, line for line:
WHITE STUFF SHOT UP OFF JIMMY'S HEAD BUT
HE DIDN'T CARE BECAUSE HE HAD SEEN SOME
WHITE STUFF SHOOTING UP OFF A CAT'S HEAD
ONCE AND ALSO SOME OF THE SAME STUFF
SHOOTING UP OFF HELEN'S HEAD AND BOTH OF
THE GIRLS MUST HAVE COME OUT OF IT OK
BECAUSE HE HAD SEEN THEM A LITTLE LATER
AND THEY SEEMED LIKE THEY WERE JUST
ABOUT THE SAME AS THEY HAD ALWAYS BEEN •
DONALD ROLLER WILSON • 6:23P.M. 1985/15 •
MONDAY • JUNE 24 ♥

Collection: Peter & Alison Baumann

PATRICIA WAS WAITING FOR EZRA POUND IN MRS. JENKINS' HALL

Oil on panel (linen over reinforced core-wood panel)
15 3/4 x 19 5/8 inches
Signed across top edge, on one line:
♥ DONALD ROLLER WILSON • 1987/22 • 6:34P.M. SUNDAY • MAY 5 •
PATRICIA WAS WAITING FOR EZRA POUND IN MRS. JENKINS' HALL

Collection: Obert & Ginny Undem

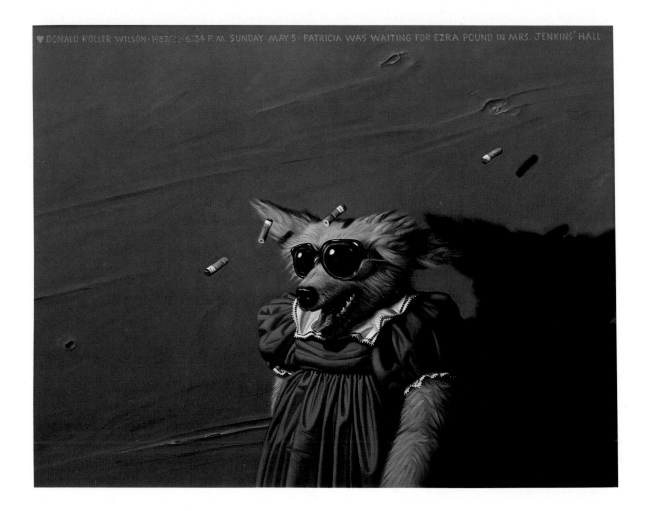

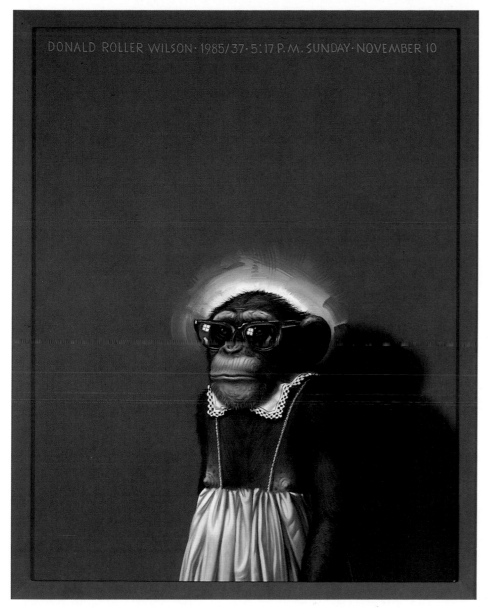

▲

JIMMY LOOKED UP THE MINUTE THE WHITE STUFF STARTED
SHOOTING OFF HIS HEAD AND HE WAS CONCERNED ABOUT IT

Oil on canvas
14 x 11 inches
Signed, upper edge on one line:
DONALD ROLLER WILSON • 1985/37 • 5:17P.M. SUNDAY • NOVEMBER 10 ♥

Collection: Kelly Gale Amen

RICHARD WAS CONCERNED ABOUT HIS BIG TRIP TO HOLLY'S ▶

Oil on canvas
49½ x 30½ inches (unframed)
55½ x 36½ inches (framed)
(Painting in upholstered frame designed by artist; frame intended as part of the art)
SHIRLEY AND KATHLEEN (BUT MAINLY SHIRLEY) MADE
RICHARD WEAR A DRESS DURING LUNCH AND THEY MADE
HIM SIT IN HIS CHAIR FROM 12:00 to 1:00 AGAINST THE
WALL IN THE HALL OPPOSITE THE DOOR LEADING TO MRS.
LAMAR JENKINS' ROOM THINKING IT WOULD BE VERY
SCARY AND A GOOD TRICK ON HIM BECAUSE THEY THOUGHT
HIS OVERPOWERING FEAR WOULD BE THAT MRS. JENKINS
WOULD CATCH HIM IN THE DRESS (MAYBE LOOKING OUT
THROUGH HER KEYHOLE AND SEEING HIM) BUT WHAT
SHIRLEY AND KATHLEEN (BUT MAINLY SHIRLEY) DIDN'T
KNOW WAS THAT WHILE RICHARD WAS AWARE OF THE
POTENTIAL EMBARRASSMENT IN THAT EPISODE, HIS WORRY
WAS OF GOING TO HOLLY SOLOMON'S IN NEW YORK AND
BEING DISCOVERED BY JOHN GLUECK, GRACE BRENSON,
KIM LARSON, KATE DeAk, PETER LINKER, EDIT LEVIN,
MICHAEL RUSSELL, ROBERTA SCHJELDAHL, KAY SMITH, OR
MRS. HEINZ (ALPHABETICALLY LISTED) ALL WHOM, FOR
INDIVIDUAL REASONS, MIGHT GET AFTER HIM • 5:44P.M.
FRIDAY • OCTOBER 12 • DONALD ROLLER WILSON • 1984/16 ♥

Collection: Laila & Thurston Twigg-Smith

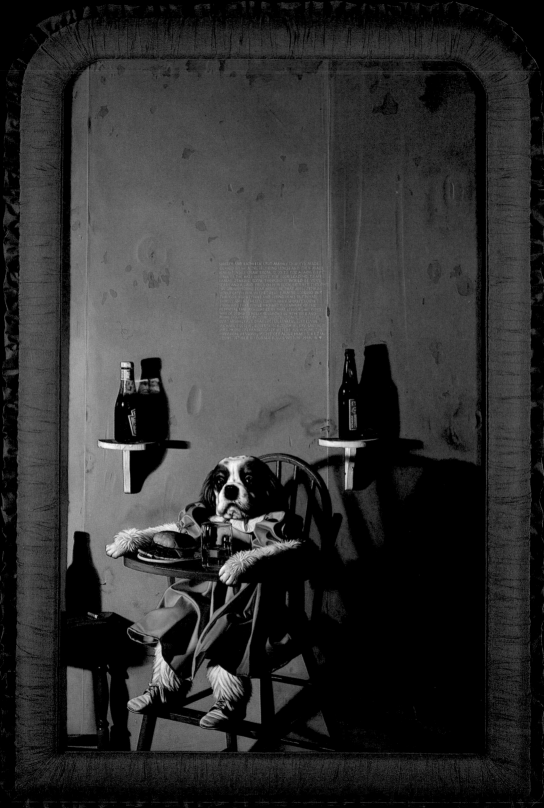

BETTY BETWEEN THE PEPPERS AGAINST ►
 THE HALL WALL
IN THE HALLWAY
 OUTSIDE MRS. JENKINS'
BEDROOM DOOR

Oil on canvas
36 x 25¾ inches (unframed)
44 x 34 inches (framed)
(Painting in upholstered frame designed by artist;
frame intended as part of the art)
Signed, lower right, on one line:
DONALD ROLLER WILSON • 1987/2 •
12:25P.M. FRIDAY • JANUARY 16 ♥

Collection: Mr. & Mrs. George Perutz

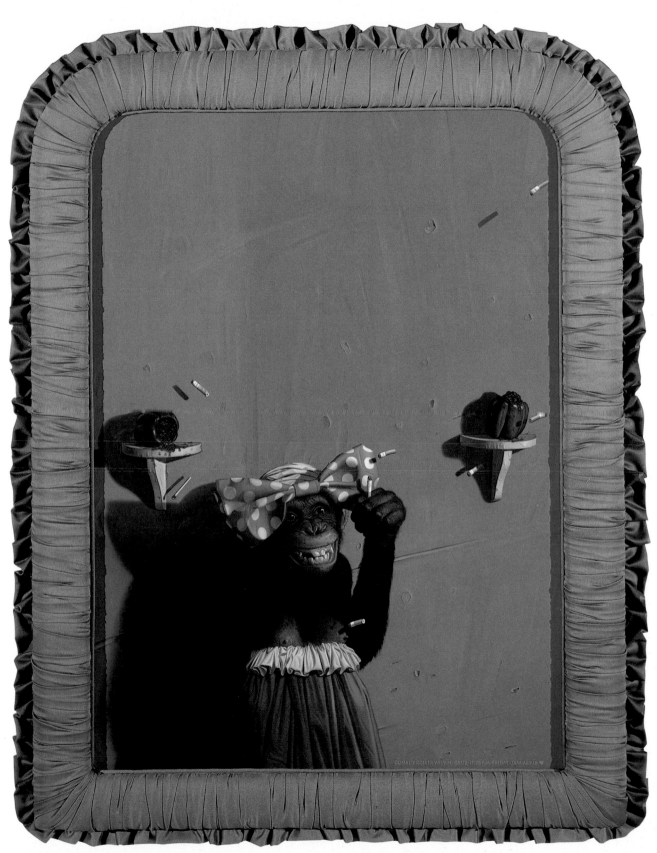

none of the hot butts were at eye level ...

Story number 1 — Mrs. Jenkins was in her room sewing on the sewing machine and she knew Jimmy was trying to peek through her keyhole because she could hear him out in the hallway — and she usually kept her keyhole plugged up so none of her friends could see inside — but, today, she noticed the keyhole was open (plus — she knew Jimmy was bored) so she thought she would kill two birds with one stone — and she turned her electric fan on at such a high speed it blew up several bits of bias tape from her sewing and several butts from her ashtray and sent them flying through the air — had enough to force them through her keyhole in an almost constant stream — and she yelled out at Jimmy through a crack in the wall that she would give him a banana for every hot butt he could spot — and he watched all day for a hot one but he just never looked down far enough (or, up far enough)

Donald Roller Wilson · 6:44 P.M. 1985/30
Saturday evening · October 19 ...

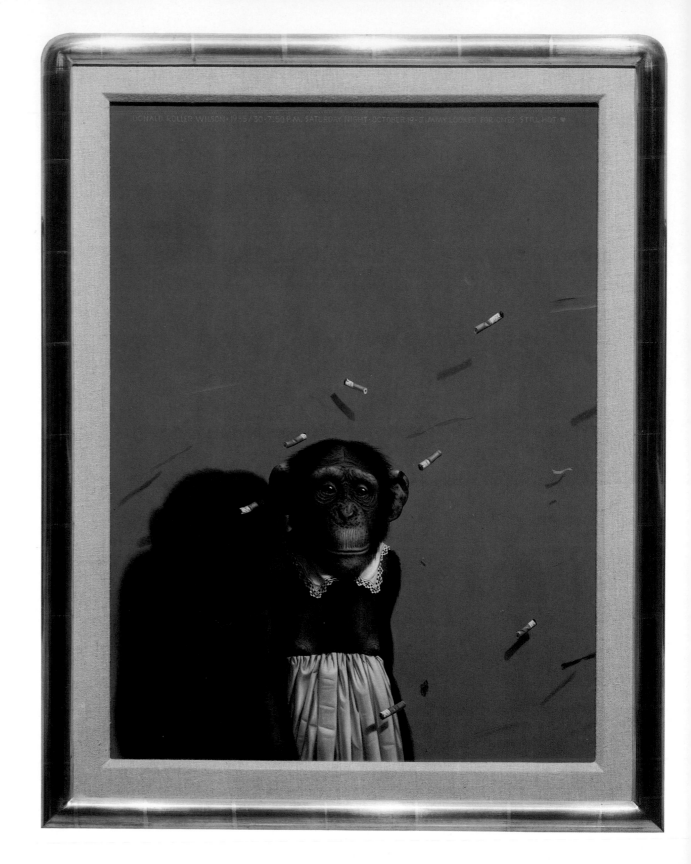

JIMMY WAS UPSET BECAUSE NONE OF THE HOT ONES WERE AT
EYE LEVEL AND THE YELLOW ONES WERE ALL SHORT

Oil on canvas and pencil on paper (three panels, framed separately)
Center canvas: 24 x 18 inches (unframed)
Side panels: 14 x 7½ inches, each (unframed)
Signed, upper edge, on one line:
DONALD ROLLER WILSON • 1985/30 • 7:50P.M. SATURDAY
NIGHT • OCTOBER 19 • JIMMY LOOKED
FOR ONE STILL HOT ♥
Handwritten ''explanation,'' left panel:
Donald Roller Wilson • 6:44P.M. 1985/30
Saturday evening • October 19…

Handwritten ''explanation,'' left panel:
None of the hot butts were at
eye level…

story number 1—Mrs. Jenkins was
in her room sewing on the sewing
machine and she knew Jimmy
was trying to peek through her
keyhole because she could hear
him out in the hallway—and
she usually kept her keyhole plugged
up so none of her friends could
see inside—but, today, she
noticed the keyhole was open
(plus—she knew Jimmy was bored)
so she thought she would kill
two birds with one stone—and
she turned her electric fan on at
such a high speed it blew up
several bits of bias tape from
her sewing and several butts
from her ashtray and sent them
flying through the air—hard
enough to force them through her
keyhole in an almost constant
stream—and she yelled out
at Jimmy through a crack in
the wall that she would give
him a banana for every hot
butt he could spot—and he
watched all day for a hot one
but he just never looked down
far enough (or, up far enough)

Donald Roller Wilson • 6:44P.M. 1985/30
Saturday evening • October 19…

Handwritten ''explanation,'' right panel:
But
and the yellow ones were all short

story number 2—Mrs. Jenkins was
in her room sewing on the sewing
machine and she knew Jimmy
was trying to peek through her
keyhole because Helen had been
out in the hall, earlier, and she
had tried to peek in too—and
since Helen and Jimmy were a
lot alike, Mrs. Jenkins just
knew Jimmy was out there trying
to peek in and it irritated her—
maybe more so today than during
another time day because it was
so hot—and her cat had been
naughty, too, and she had been
smoking too much (Mrs. Jenkins)—
so, she just set her ash tray
along with some scraps of bias tape
from her sewing in front of the
keyhole—up on the table where
the fan was going—and she
turned the fan way up so it blew
the whole mess right out through
the keyhole and into the air in
the hallway right past Jimmy
and, later, Mrs. Jenkins tried to
make up by yelling out a crack in
the wall that she would give
Jimmy a banana for every long
piece of yellow bias tape he found

Donald Roller Wilson • 7:39P.M. 1985/30
Saturday, evening • October 19…

Collection: Jerald Dillon Fessenden

101

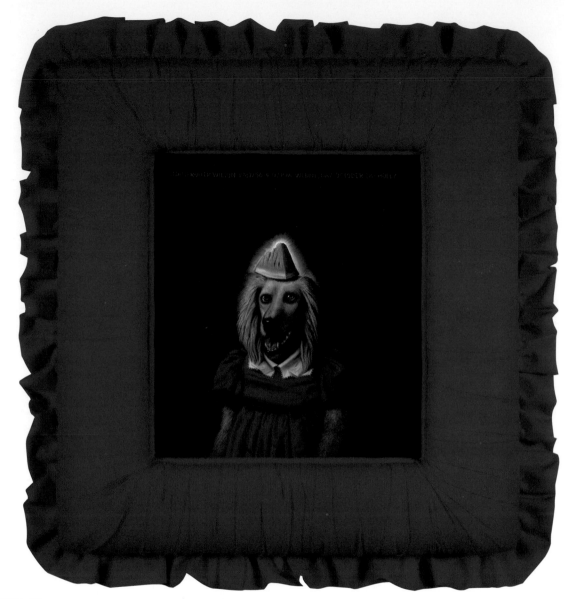

HOLLY (FRIEND OF PATRICIA) DIDN'T SEE THE WRITING ON
THE WALL (A MESSAGE WHICH HAD BEEN LEFT BY PATRICIA)
WHICH PATRICIA HAD HAD JIMMY WRITE WITH HIS PENCIL
ON THE WALL OUTSIDE MRS. JENKINS' BEDROOM DOOR SO
THAT WHEN HOLLY SHOWED UP SHE WOULD SEE (AND, HOLLY
DID SHOW UP BUT SHE STOOD WITH HER BACK AGAINST THE
WALL AND NEVER DID TURN AROUND)

Oil on linen
(Painting in upholstered frame designed by artist; frame intended as part of the art)
10 x 9 inches (unframed)
19 x 18 inches (framed)
Signed, upper edge:
DONALD ROLLER WILSON • 1987/56 • 4:07P.M. WEDNESDAY • OCTOBER 28 • HOLLY
Signed, upper center,
if you can read this, you're too close…

Collection: John Berggruen Gallery, San Francisco, California

A SMALL UPDATED PORTRAIT OF HOLLY SOLOMON AS A YOUNG BLONDE

Oil on canvas on panel
11¼ x 9 inches
Signed, upper edge:
DONALD ROLLER WILSON • 1984/5 • 7:27P.M. APRIL 3 • TUESDAY ♥
Signed, center, on one line in cadmium letters:
I..I'M SORRY

Collection: Holly Solomon, New York

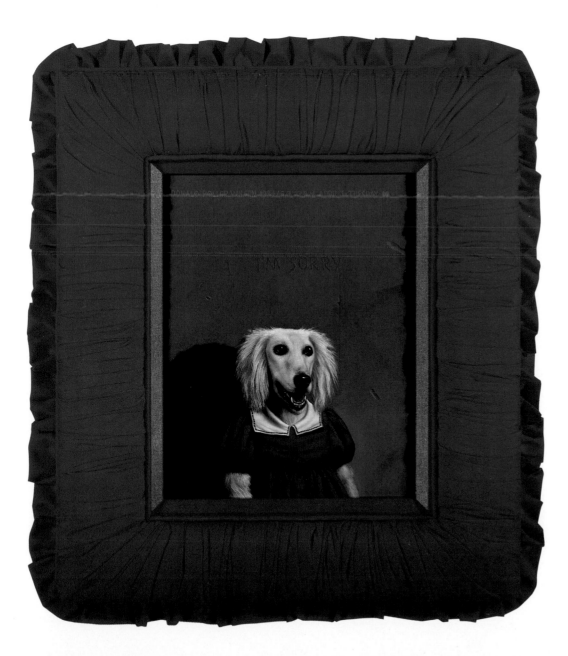

HELEN WONDERED WHAT SHE COULD DO...HELEN
(HELEN'S SIAMESE TWIN SISTER) HAD DONE A JOB
IN HER PANTS AT SCHOOL AND THE TEACHER MADE
HER STAY AFTER AND HELEN HAD NEVER HAD TO BE
AWAY FROM HELEN FOR MUCH AT A TIME AND WHEN-
EVER SHE DID SHE ALWAYS WONDERED WHAT TO DO

Oil on canvas
9½ x 12 inches (unframed)
19 x 21 inches (framed)
(Painting in upholstered frame designed by the artist; frame
intended as part of the art)
Signed, center left, line for line:
DONALD ROLLER WILSON • 1985/7 • 2:09P.M. GOOD FRIDAY • APRIL 5 • HELEN
Signed, center right, in cadmium red letters:
What to do...

Collection: Mr. & Mrs. O. Kelley Anderson, Jr.

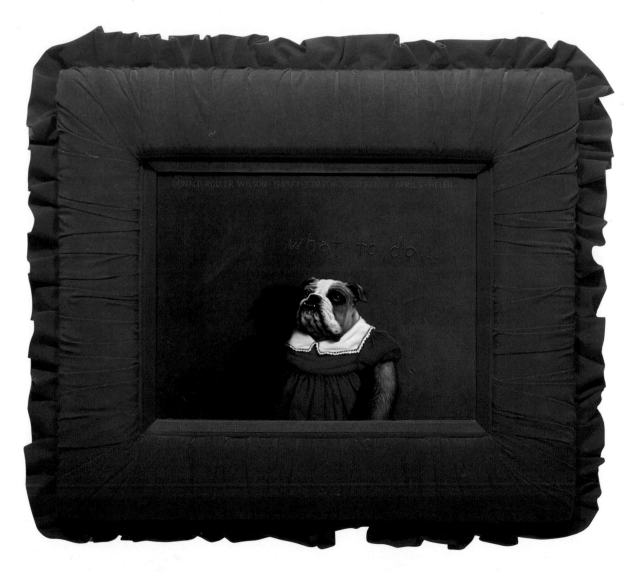

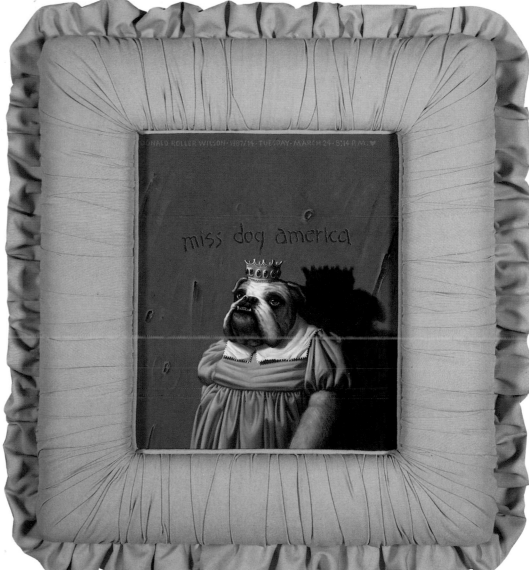

HELEN (THE NAUGHTY ONE) WINS MISS DOG AMERICA

HELEN HAD BEGGED MRS. JENKINS TO BUY HER A NEW
DRESS FOR THE MISS DOG AMERICA CONTEST WHICH HAD
BEEN CONCEIVED BY BETTY AND JIMMY AND WHICH WAS
HELD IN THE HALLWAY OUTSIDE MRS. JENKINS' BEDROOM
DOOR BUT MRS. JENKINS DIDN'T BUY HER ONE BUT HELEN
HAD WON ANYWAY BECAUSE BETTY HAD TOLD HER THAT
SHE WOULD WIN IF SHE WOULD GIVE RICHARD A BIG KISS
AND THAT SINCE RICHARD WAS THE JUDGE IT WOULD WORK
AND IT DID WORK AND HELEN WON

Oil on canvas
11 x 9 inches (unframed)
19 x 17 inches (framed)
(Painting framed in upholstered frame designed by
the artist; frame intended as part of the art)
Signed, upper edge, on one line:
DONALD ROLLER WILSON • 1987/14 • TUESDAY • MARCH 24 • 8:14P.M. ♥
Signed, upper center, in cadmium red letters:
miss dog america
Collection: Dr. Gerard & Phyllis Seltzer

105

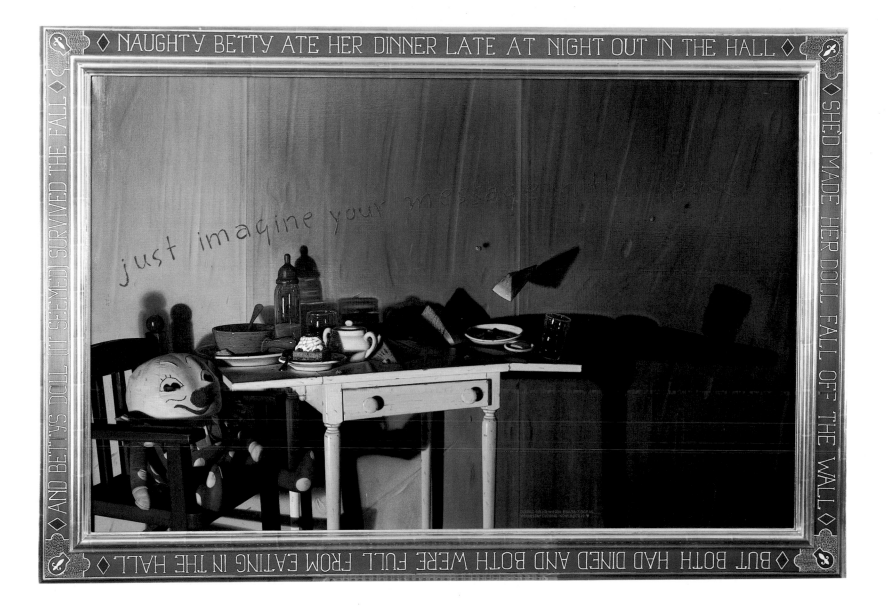

HUMPTY'S LATE-NIGHT SNACK

NAUGHTY BETTY ATE HER DINNER
LATE AT NIGHT OUT IN THE HALL
BUT MRS. JENKINS STAYED INSIDE HER ROOM

SHE DIDN'T WANT TO EAT WITH BETTY
LATE AT NIGHT OUT IN THE HALL
SO HAD A FROZEN DINNER IN HER ROOM

NAUGHTY BETTY HAD BEEN BAD
SHE'D MADE HER DOLL FALL OFF THE WALL
SO MRS. JENKINS STAYED INSIDE HER ROOM

BUT ALL HAD DINED—AND ALL WERE FULL
AND BETTY'S DOLL SURVIVED THE FALL
BUT MRS. JENKINS STAYED INSIDE HER ROOM

Oil on canvas
32½ x 50 inches (unframed)
40½ x 58 inches (framed)
(Painting in frame designed by artist; frame intended
as part of the art)
Printed around frame, line for line:
NAUGHTY BETTY ATE HER DINNER LATE AT NIGHT IN THE HALL
SHE'D MADE HER DOLL FALL OFF THE WALL
BUT BOTH HAD DINED AND BOTH WERE FULL FROM EATING IN THE HALL
AND BETTY'S DOLL (IT SEEMED) SURVIVED THE FALL
Signed, lower center, right:
DONALD ROLLER WILSON • 1986/18 • 7:00P.M.
WEDNESDAY EVENING • NOVEMBER 19 • ♥
Signed, upper center, in cadmium red letters:
just imagine your message in this space

Collection: Private, New York

107

LARRY'S MATCH AND LITTLE BETTY'S MELON

Oil on masonite panel
6¼ x 7¼ inches
Signed, lower center:
DONALD ROLLER WILSON • 1982/24
7:46P.M. SATURDAY • MAY 22

Collection: John James Hancock/Guy C. Johnson

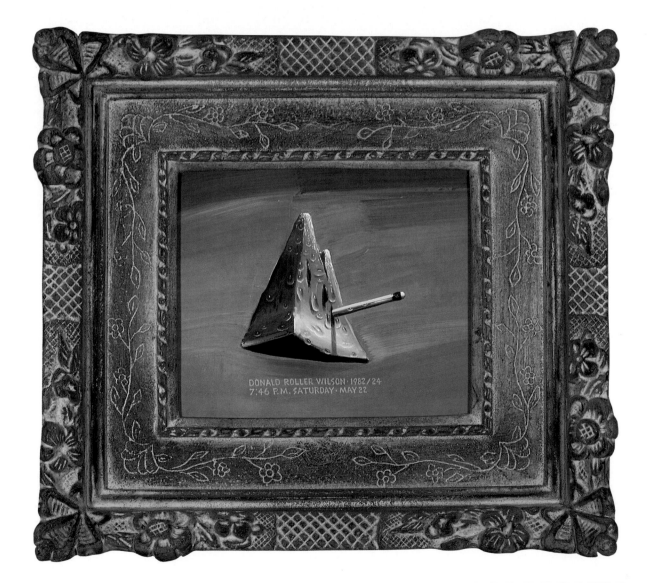

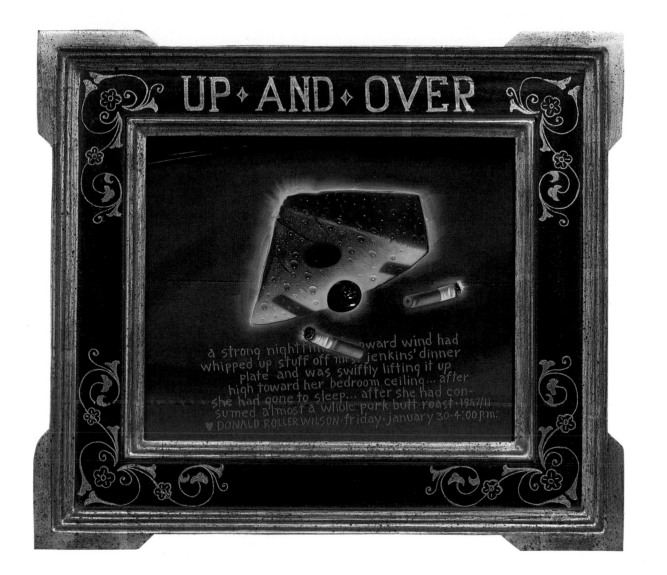

UP AND OVER

Oil on panel (linen over wood)
7¼ x 8¾ inches (unframed)
11¾ x 13¼ inches (framed)
(Painting in frame designed by artist; frame intended
as part of the art)
Printed, top of frame:
UP AND OVER
Signed, lower center:
a strong nighttime upward wind had
whipped up stuff off mrs. jenkins' dinner
plate and was swiftly lifting it up
high toward her bedroom celing…after
she had gone to sleep…after she had con-
sumed almost a whole pork butt roast • 1987/11
♥ DONALD ROLLER WILSON • friday • january 30 • 4:00p.m.
Collection: Ms. Alicia Lazaro Goldstein

109

MRS. JENKINS' DREAM OF HER SISTER (MRS. WHITE) WHO
REMAINED AT 405 LEXINGTON AVENUE ALL DURING THE 118
YEARS SINCE MRS. JENKINS HAD MOVED TO ARKANSAS

Oil on panel (linen over wood)
7 x 8½ inches (unframed)
11 5/8 x 12 5/16 inches (framed)
(Painting in frame designed by artist; frame intended
as part of the art).
Printed, top of frame:
NIGHTTIME
Signed, top edge, in cadmium red letters, line for line:
NIGHTTIME HAD COME AND MRS. JENKINS WAS SOUND
ASLEEP IN HER BEDROOM AND HADN'T SEEN THE BIG
HOT BUTT OVER HER SMALL LITTLE HOUSE
Signed, bottom edge, on one line:
DONALD ROLLER WILSON • 1986/19 • SUNDAY • DECEMBER 21 • EXACTLY 7:00P.M.
IN REACH

Collection: Laila & Thurston Twigg-Smith

COOKIE RAN ALONG WITH THE BIG DILLS ►

Oil on canvas
10 x 22 inches
(Painting in frame designed by artist; frame intended as part of the art)
Printed around frame, line for line:
THE BIG DILLS CAME
GOING
THE BIG DILLS WENT
COMING
Signed, upper edge, on one line:
♥ DONALD ROLLER WILSON • 1986/1 • 7:17P.M.
TUESDAY • MARCH 18 • THREE BIG DILLS FOLLOWED AND
TWO LED THE WAY • AND COOKIE RAN WITH THEM

Collection: Robin Williams

▼

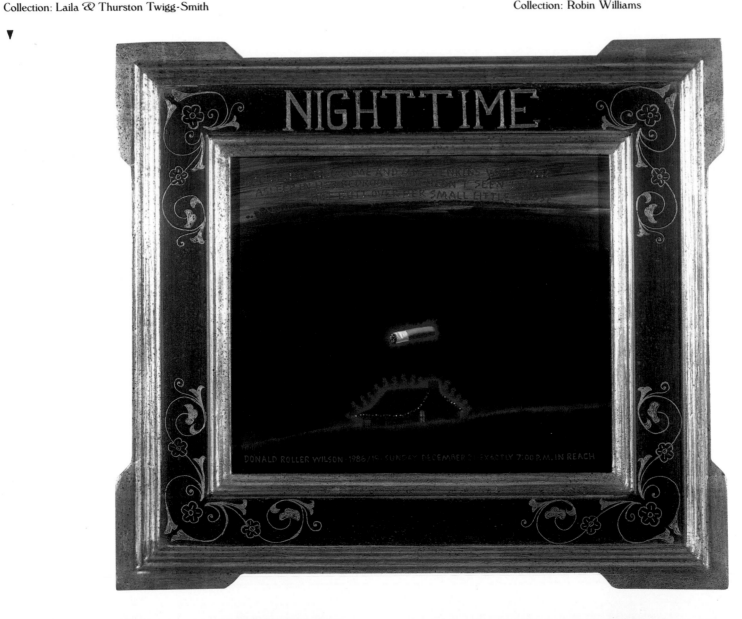

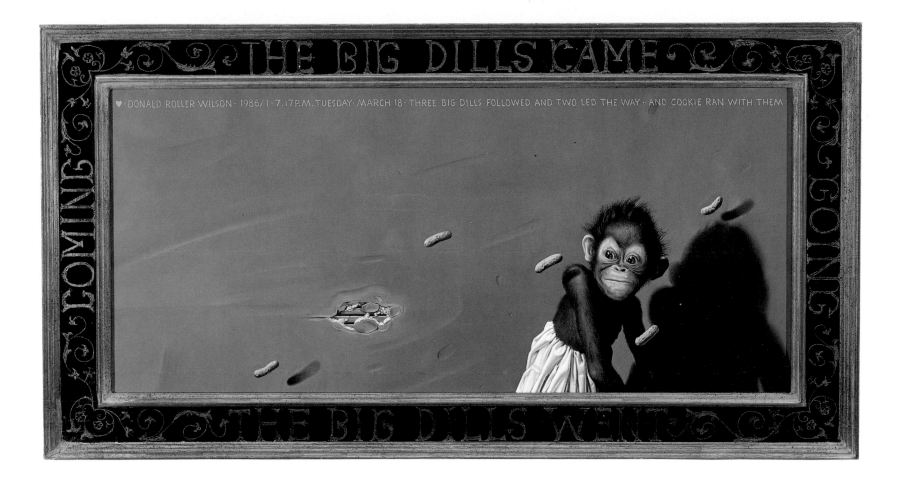

A STRONG NIGHT WIND HAD COME THROUGH MRS. JENKINS'
HALLWAY STIRRING UP THOUGHTS OF GREAT WEALTH WHICH
CAME FROM A SLOT ABOVE THE BRAIN OF HER PIGGY BANK
WHICH HAD BEEN TRANSFORMED (DURING THE WIND) FROM
A PIG INTO A MOUSE

MRS. JENKINS' PIGGY BANK
HAD TURNED INTO A MOUSE
SHE KEPT IT FULL BENEATH HER BREAKFAST PLATE

BUT WHEN IT TURNED INTO THE MOUSE
A PIG WAS STILL AROUND
SHE TRIED TO KEEP THEM FULL BUT COULDN'T WAIT

THE FUNDS WERE SLOW IN COMING
WHICH SHE NEEDED FOR THE TREATS
TO FEED BOTH BANKS AND MULTIPLY THEIR WEIGHT

SO, MRS. JENKINS SENT THE PIG
BACK EAST TO SISTER WHITE
WHO'D SWORN THAT SHE COULD MAKE ITS SHAPE DILATE

Oil on canvas
49 x 42 inches

(Painting in frame designed by artist; frame intended as part of the art)
Printed around frame, line for line:
A STRONG WIND HAD COME THROUGH THE HALL
STIRRING UP THOUGHTS OF GREAT WEALTH AND SIGNS OF MONEY
WHICH CAME FROM THE BRAIN OF MRS. JENKINS' BANK
WHICH THE HIGH WINDS HAD CHANGED FROM A PIG TO A MOUSE
Signed, lower night, on one line:
DONALD ROLLER WILSON • 1987/1 • WEDNESDAY EVENING •
JANUARY 7 • 7:00P.M. EXACTLY
Signed, upper center, in cadmium red letters:
a strong night wind

Collection: Dr. Jerry Sherman, Baltimore, Maryland

111

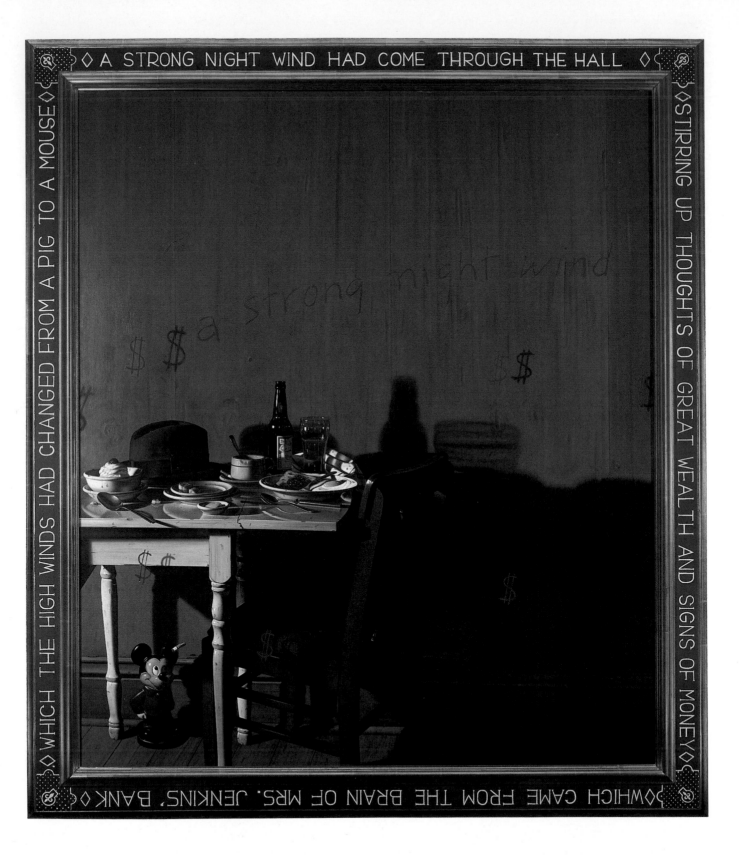

112

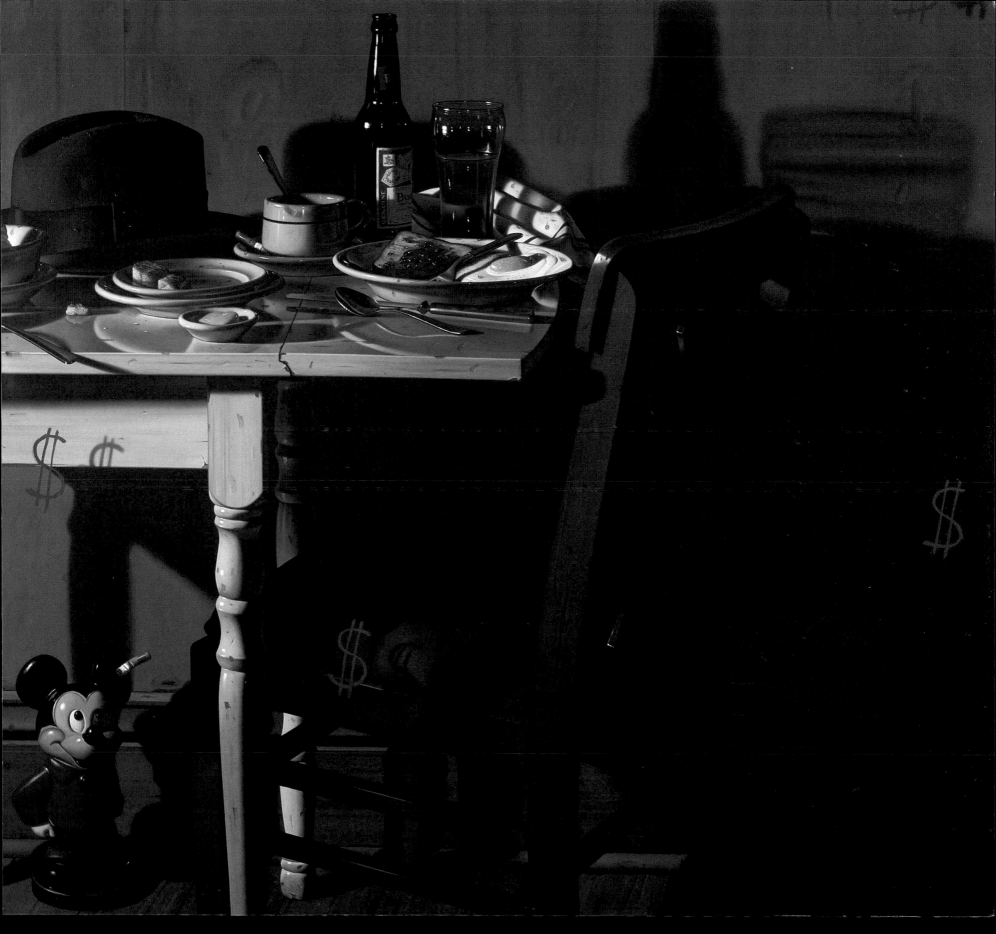

HOLLY HAD BEEN IN MRS. JENKINS' HALL
WHERE SHE HAD HELD REAL STILL
SO THAT MRS. JENKINS WOULDN'T GET MAD
IN CASE HOLLY'S BOTTLE MIGHT FALL

Oil on canvas
16 x 19 inches (unframed)
21¾ x 24¾ inches (framed)
(Painting in hand-lettered frame designed by the artist;
frame intended as part of the art)

Signed, upper edge, on one line
DONALD ROLLER WILSON • 1987/58 • FULL MOON • 6:06P.M. WEDNESDAY •
NOVEMBER 4 • HOLLY LOOKED UP TO MAKE SURE IT WAS STILL THERE...
AND IT WAS... IT WAS OK...
Signed, around edges of frame, on four lines:
HOLLY HAD BEEN IN MRS. JENKINS' HALL
WHERE WHE HAD HELD REAL STILL
SO THAT MRS. JENKINS WOULDN'T GET MAD
IN CASE HOLLY'S BOTTLE MIGHT FALL

Collection: Private

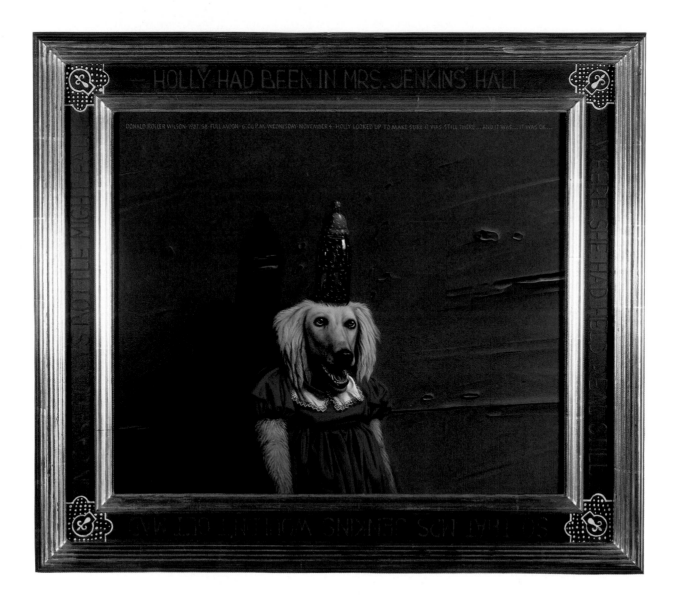

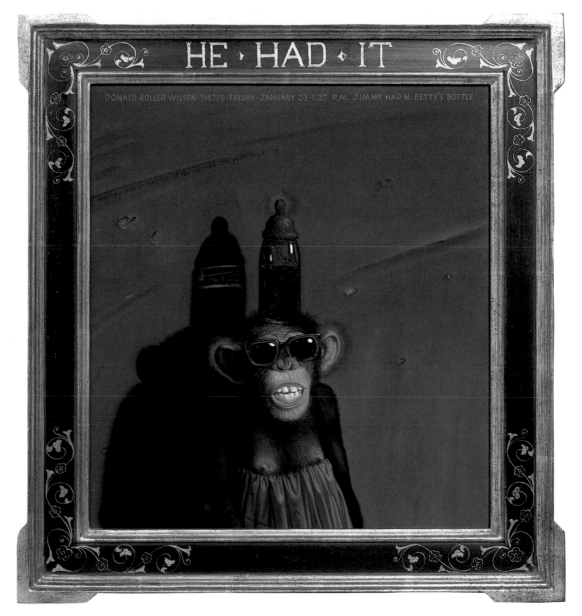

MRS. JENKINS HAD TOLD JIMMY THAT UNTIL HE
ACTED LIKE HE SHOULD HE COULDN'T HAVE ANY
OF NAUGHTY BETTY'S BOTTLE ANYMORE BUT MRS.
JENKINS WAS ASLEEP IN HER BEDROOM AND JIMMY
GRABBED IT AWAY FROM BETTY AND HE HAD IT AND
MRS. JENKINS FOUND OUT LATER AND GOT AFTER HIM

Oil on panel (linen over wood)
15½ x 14 inches (unframed)
20 x 18½ inches (framed)
(Painting in frame designed by artist; frame intended
as part of the art)
Signed, upper edge, on one line:
DONALD ROLLER WILSON • 1987/5 • FRIDAY • JANUARY 23 • 1:37P.M.
JIMMY HAD N. BETTY'S BOTTLE
Signed, upper left, in raw umber letters:
oh, hey vivien raynor…if you can read this you're too close

Collection: Mr. & Mrs. George Perutz

115

MRS. JENKINS HAD SMOKED SO MUCH DURING THE EXCITEMENT
OF THE EVENING OF THE MISS AMERICA CONTEST IN HER
HALLWAY THAT BY NEXT MORNING THE BIG HOT BUTTS (WHICH
WENT UP THROUGH THE CHIMNEY AND INTO THE SKY ABOVE HER
HOUSE) HAD FINALLY STARTED TO COME DOWN AND ONE HAD MADE
IT ALL THE WAY AND ONE WAS JUST ABOVE THE LAWN AND ONE
WAS JUST ABOUT TO LAND ON HER ROOF BUT JUST IN THE NICK
OF TIME A FREAK DAYTIME HIGH WIND CAME WHIPPING UP AND
BLEW IT TO THE SIDE WHERE IT TOOK ANOTHER COURSE

Oil on panel (linen over mahogany)
4 x 5 inches
Signed, lower edge:
DONALD ROLLER WILSON • 87/50 MRS. JENKINS' BUTTS
Signed, upper third, gray letters, line by line:
ONE WAS ALMOST ON THE ROOF
AND ONE WAS VERY NEAR THE
GROUND AND ONE
Signed, on back of panel:
87/50 !
2:00P.M.
SUNDAY
JULY 26

Collection: Private

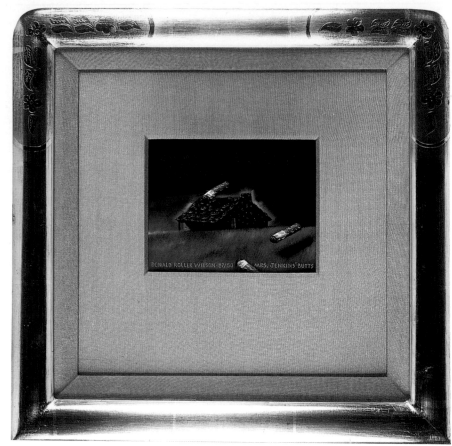

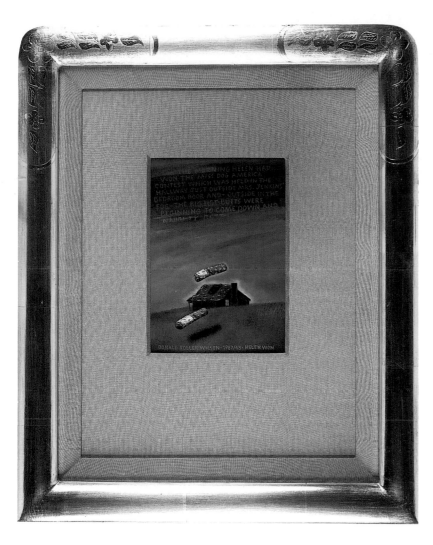

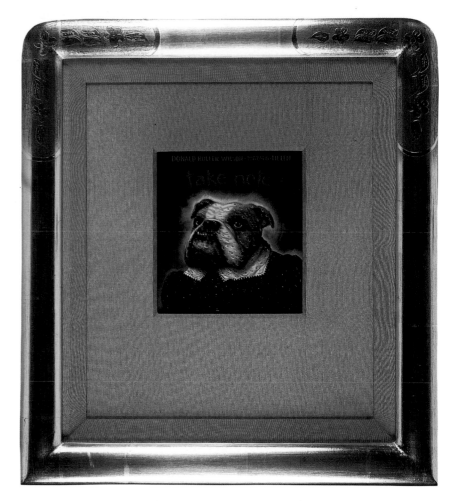

MRS. JENKINS WAS ASLEEP IN HER ROOM EARLY IN THE
MORNING FOLLOWING THE LATE-NIGHT MISS DOG AMERICA
CONTEST WHICH HAD BEEN HELD IN THE HALLWAY JUST
OUTSIDE HER BEDROOM DOOR

Oil on panel (linen over mahogany)
5¾ x 4 inches
Signed, lower edge:
DONALD ROLLER WILSON • 1987/45 • HELEN WON
Signed, upper fourth of panel, in cadmium red letters:
THE MORNING HELEN HAD
WON THE MISS DOG AMERICA
CONTEST WHICH WAS HELD IN THE
HALLWAY JUST OUTSIDE MRS. JENKINS'
BEDROOM DOOR AND—OUTSIDE IN THE
FOG—THE BIG HOT BUTTS WERE
BEGINNING TO COME DOWN AND
NAUGHTY BET

Collection: Samuel X. Kaplan

HELEN HAD CHANGED HER DRESS AND REMOVED HER CROWN FOR
THE NIGHT (FOLLOWING WINNING MISS DOG AMERICA) BUT SHE
WAS WAY TOO HOT TO GO TO BED SO SHE THOUGHT SHE WOULD
WAKE UP NAUGHTY BETTY AND THEY COULD LOOK OUT THE HOLE
IN THE CEILING OF THE HALLWAY TOGETHER AND WATCH THE
BIG HOT BUTTS WHICH CAME DOWN FROM THE SKY EVERY MORNING

Oil on panel (linen over mahogany)
4¾ x 4½ inches
Signed, upper edge:
DONALD ROLLER WILSON • 1987/46 • HELEN ♥
Signed, upper third in cadmium red letters:
take note
Signed, on back of panel:
87/46
8:18P.M.
WEDNESDAY
JULY 22

Collection: Private

117

WHEN MRS. JENKINS FOUND THAT TWO CANS OF CREAM CORN
HAD BEEN BLOWN OUT OF HER CUPBOARD BY THE STRONG NIGHT
WINDS WHICH WHIPPED THROUGH HER HALLWAY EVERY NIGHT
SHE TRIED TO WEIGHT HER REMAINING SUPPLY DOWN WITH A
PLUG WHICH SHE HAD REMOVED FROM A MELON EARLIER IN THE
DAY BUT IT WAS TOO LIGHT AND THE NEXT NIGHT SHE LOST
TWO MORE CANS ALONG WITH SOME NAVY BEANS AND A DISHRAG
AND A HOT BUTT WHICH GOT WET IN THE RAIN THAT THE WIND
BROUGHT IN WITH IT

Oil on panel (linen over mahogany)
3 x 4 inches
Signed, bottom edge
DONALD ROLLER WILSON • 1987/41 • STRONG WIND
Signed, lower center, in cadmium red letters:
cream corn
Signed, on back of panel:
87/41
5:02P.M.
Monday July 13

Collection: Samuel X. Kaplan

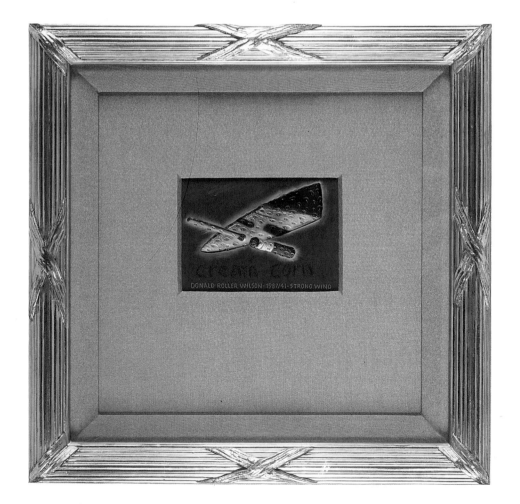

118

MRS. JENKINS HAD PUT ON BRIGHT RED FRESH LIPSTICK
JUST BEFORE THE STRONG NIGHT WINDS GOT HARD ENOUGH
TO WHIP HER HOT BUTT RIGHT UP INTO THE AIR NEAR THE
HIGH CEILING OF HER HALLWAY WHERE NAUGHTY BETTY'S
KITCHEN MATCH HAD BECOME TOO WET TO LIGHT AND WHERE
BOTH OBJECTS GOT CLOSER AND CLOSER TOGETHER THE CLOSER
THEY BOTH GOT TO THE WALL WHERE THE WRITING WAS (ON) THE
WALL IN BRIGHT RED LETTERS WHICH SAID (GOD IS NEAR)

Oil on panel (linen on mahogany panel)
3¾ x 3 inches
Signed, upper edge:
DONALD ROLLER WILSON • 87/37
Signed, upper center, in cadmium red letters:
God is near
Signed, on back of panel:
1:11P.M.
THURSDAY
JULY 9 87/37

Collection: Private

MRS. JENKINS' EAR GOT HOT WHEN SHE FINALLY FIGURED
OUT WHAT NAUGHTY BETTY HAD TOLD HER EARLIER IN THE
EVENING (ABOUT HOW HELEN HAD WON MISS DOG AMERICA)

Oil on panel (linen over mahogany)
3¼ x 2¼ inches
Signed around edge of image:
4:50P.M. TUESDAY • JULY 7 • ♥ WAS THE DAY WHEN HER
EAR GOT REAL HOT • ♥ DONALD ROLLER WILSON • 1987/34
Signed, on back of panel:
1987/34
4:50P.M.
TUESDAY
JULY 7

Collection: Private

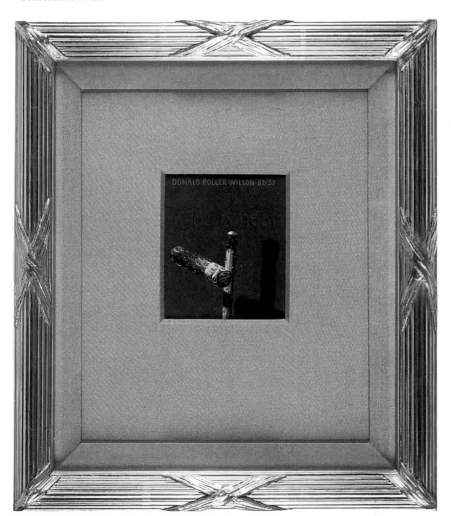

BEVERLY HAD COME TO THE HALLWAY OUTSIDE MRS. JENKINS'
BEDROOM DOOR AND IT SEEMED TO HER THAT SHE HAD BEEN
WAITING FOR A VERY VERY LONG TIME (IN FACT, PATRICIA
AND JIMMY WHO HAD ALSO BEEN WAITING HAD ALREADY GONE
BACK OUTSIDE) (FOR A WHILE) AND BEVERLY STARTED TO
HAVE SOME VERY BASIC THOUGHTS WHICH WERE, WELL, PRIMARY,
AND HER THOUGHTS WERE BEGINNING TO SEEP OUTWARD FROM
HER MIND AS SHE WAITED

Oil on canvas
9 x 17 inches (unframed)
12¾ x 20¾ inches (framed)
(Painting in frame designed by the artist; frame intended as part of the art)
Printed around frame, line for line:
BEVERLY'S PRIMARY THOUGHTS
WERE BEGINNING
TO SEEP OUTWARD FROM HER MIND
AS SHE WAITED
Signed, center, in cadmium red and blue letters:
She had waited—VERY LONG TIME
Signed, bottom edge, on one line:
DONALD ROLLER WILSON • 1987/17 • BEVER—DN'T
TOO LONG • 2:45P.M. MONDAY • APRIL 13

Collection: Private

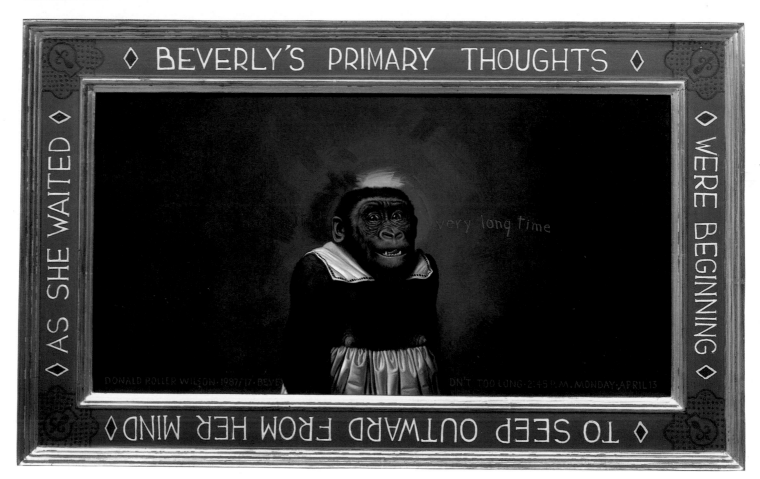

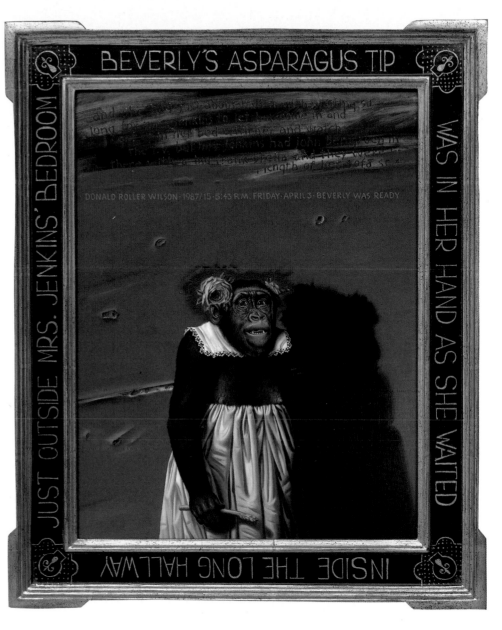

BEVERLY KNEW SHE WOULD NEVER FIT IN IN CALIFORNIA BECAUSE SHE WAS TOO COMPLEX AND, BESIDES, HER HEAD WAS FILLED WITH RECOGNIZABLE SUBJECT MATTER, AND HER FRIEND JOHN WHO WAS A FAMOUS CALIFORNIA AGENT (WHO HAD PLACED MANY FINE APES IN HOMES ACROSS AMERICA WITH THE EXCEPTION OF CALIFORNIA ONES) HAD TOLD HER SHE BETTER STAY IN ARKANSAS AND LEAVE CALIFORNIA TO FRANK (WHO HAD NO RECOGNIZABLE SUB-JECT MATTER—ANYWHERE) AND, SO, SHE DID, AND, ONE DAY, JOHN HAD COME TO ARKANSAS AND TRIED TO INTEREST MRS. JENKINS IN SOMETHING FOR ABOVE HER SOFA, AND BEVERLY WAS FURIOUS BECAUSE THE PRESENTATION (WHICH TOOK PLACE IN MRS. JENKINS' BEDROOM WHERE THE T.V. WAS) HAD SPOILED HER VIEWING

Oil on canvas
16 x 12 inches (unframed)
20¼ x 16½ inches (framed)
(Painting in frame designed by artist; frame intended as part of the art)
Printed around frame, line for line:
BEVERLY'S ASPARAGUS TIP
WAS IN HER HAND AS SHE WAITED
INSIDE THE LONG HALLWAY
JUST OUTSIDE MRS. JENKINS' BEDROOM
Signed, upper edge, in cadmium red letters, line for line:
and she had just about had it with waiting so
long for mrs. jenkins to let her come in and
get up in her bed with her and watch
the t.v. but mrs. jenkins had john berggruen in
there with a big frank stella and they were
 length of her sofa so
Signed, upper third, on one line:
DONALD ROLLER WILSON • 1987/15 • 5:43P.M. FRIDAY • APRIL 3 • BEVERLY WAS READY

Courtesy: Mr. & Mrs. John Berggruen

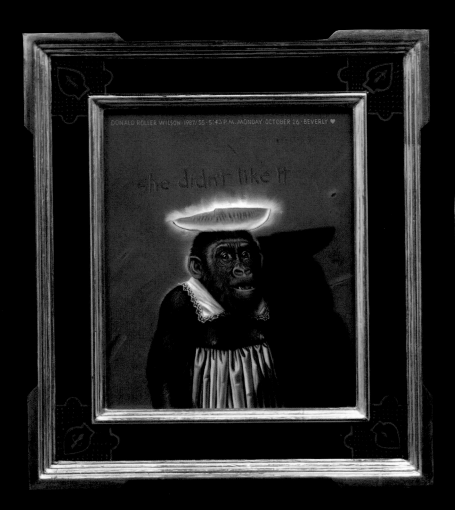

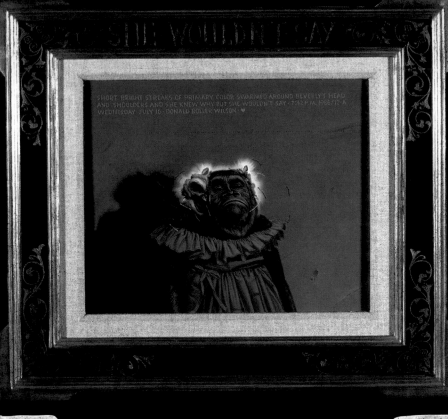

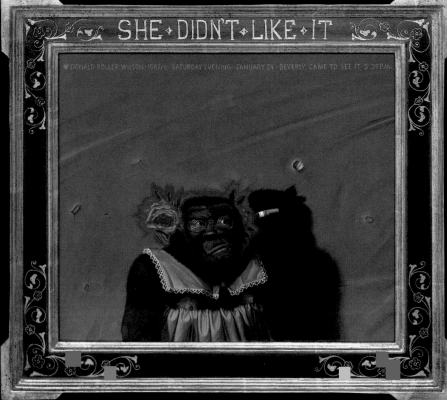

BEVERLY KNEW THE SIGNS OF ART WERE PRIMARY BUT SHE
WOULDN'T TELL ANYONE BECAUSE SHE WANTED TO BE THE
ONLY ONE TO KNOW

Oil on linen (linen, hand prepared, attached
nforce wood panel)
10 x 12 inches
(Painting in frame designed by artist; frame intended as part of the art)
Printed, top of frame:
SHE WOULDN'T SAY
Signed, upper edge, on three lines:
SHORT BRIGHT STREAKS OF PRIMARY COLOR SWARMED AROUND BEVERLY'S HEAD
AND SHOULDERS AND SHE KNEW WHY BUT SHE WOULDN'T SAY 7:42P.M./12-A
WEDNESDAY JULY 16 DONALD ROLLER WILSON

Collection: Private

MRS. JENKINS HAD TOLD NAUGHTY BETTY TO TELL BEVERLY
THAT IF SHE (BEVERLY) WOULD COME STAND OUTSIDE
HER (MRS. JENKINS') BEDROOM DOORWAY THAT SHE (MRS. JENKINS)
WOULD STICK OUT A NEW HAT UNDER THE CRACK IN THE DOOR...
FOR BEVERLY...BUT NAUGHTY BETTY MADE SURE SHE BEAT
BEVERLY TO THE DOORWAY AND SHE GOT THE HAT AND LEFT A
BIG SLICE OF MELON WHERE THE HAT HAD BEEN AND WHEN BEVERLY
SHOWED UP AND SPOTTED IT (THE MELON) SHE THOUGHT IT WAS
THE NEW HAT AND THAT MRS. JENKIN HAD TRIED TO TRICK
HER AND...SHE DIDN'T LIKE IT

Oil on panel (linen over mahogany)
9½ x 8 inches
Signed, upper edge:
DONALD ROLLER WILSON • 1987/55 • 5:43P.M. MONDAY • OCTOBER 26• BEVERLY ♥
Signed, upper third, in cadmium red letters:
She didn't like it

Collection: Morton Rutherfurd

NAUGHTY BETTY HAD TOLD BEVERLY TO COME TO
THE HALLWAY OUTSIDE MRS. JENKINS' BEDROOM
DOOR AND SHE WOULD SEE SOMETHING AND BEVERLY
DID AS SHE WAS TOLD AND SHE DIDN'T LIKE IT!

Oil on panel (linen over wood)
12½ x 14½ inches (unframed)
17 x 19 inches (framed)
(Painting in frame designed by artist; frame intended as part of the art)
Printed, top of frame:
SHE DIDN'T LIKE IT
Signed, upper edge, on one line:
♥ DONALD ROLLER WILSON • 1987/6 • SATURDAY EVENING • JANUARY 24 • BEVERLY
CAME TO SEE IT • 5:39P.M.

Collection: Mr. & Mrs. George Perutz

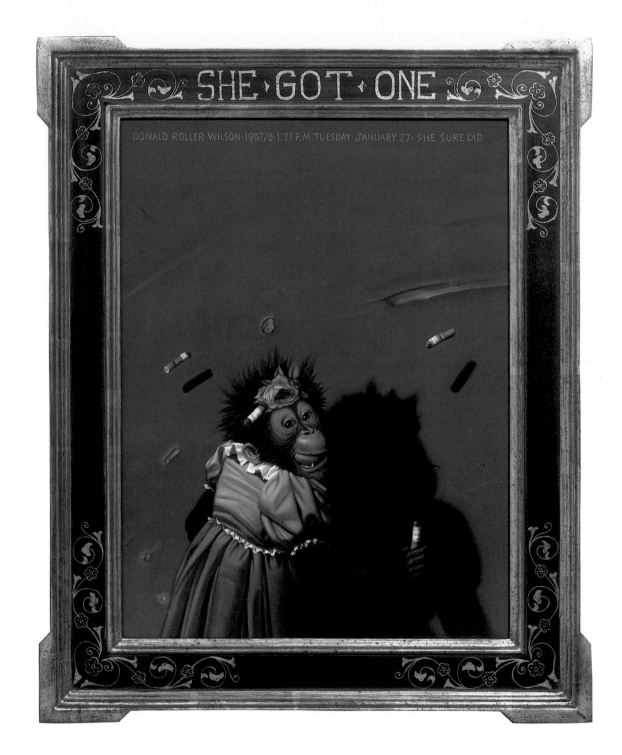

COOKIE HAD STAYED IN THE HALLWAY OUTSIDE MRS. JENKINS'
BEDROOM DOOR LONG AFTER BEVERLY AND BETTY HAD GONE TO
HAVE THEIR DINNER AND SHE GOT ONE

Oil on panel (linen on wood)
16 x 12 inches (unframed)
20 3/8 x 16 3/8 inches (framed)
(Painting in frame designed by artist, frame intended as part of the art)
Printed, top of frame:
SHE GOT ONE
Signed, upper edge, one line:
DONALD ROLLER WILSON • 1987/8 • 1:21P.M. TUESDAY • JANUARY 27 • SHE SURE DID

Collection: Private

SOLO EXHIBITIONS

1988 *Roller: The Paintings of Donald Roller Wilson*, organized and toured by Mid-America Arts Alliance, Kansas City, Missouri; traveling to The Arkansas Art Center, Little Rock; The Fine Arts Center, Nashville, Tennessee; Oklahoma Art Center, Oklahoma City; Huntsville Museum of Art, Huntsville, Alabama; Art Museum of South Texas, Corpus Christi.
Jan Turner Gallery, Los Angeles, California

1987 Coe Kerr Gallery, New York, New York

1985 Moody Gallery, Houston, Texas
Holly Solomon Gallery, New York, New York

1984 *Visitors to Mrs. Jenkins' Room*, Holly Solomon Gallery

1982 Fendrick Gallery, Washington, D.C.
Virginia Miller Galleries, Coral Gables, Florida

1981 Moody Gallery, Houston, Texas
Marilyn Butler fine Art, Scottsdale, Arizona

1979 Moody Gallery, Houston, Texas
University Fine Arts Gallery, Florida State University, Tallahassee, Florida
University of Arkansas, Fayetteville, Arkansas

1978 University of North Dakota, Grand Forks, North Dakota
John Berggruen Gallery, San Francisco, California

1977 Moody Gallery, Houston, Texas

1976 University of Tulsa, Tulsa, Oklahoma
Phillips University, Enid, Oklahoma

1975 David Findlay Gallery, New York, New York

1974 La Jolla Museum of Contemporary Art, La Jolla, California

1973 Tibor de Nagy Gallery, Houston, Texas

1972 Virginia Commonwealth University, Richmond, Virginia

1970 David Gallery, Houston, Texas
Nelson Gallery of Art and Mary Atkins Museum of Fine Arts, Kansas City, Missouri
Museum of Fine Arts, Kansas City, Missouri
The City Art Museum of St. Louis, St. Louis, Missouri

1969 Sheldon Memorial Gallery, University of Nebraska, Lincoln, Nebraska
Contemporary Arts Museum, Houston, Texas

1966 Wichita Art Museum, Wichita, Kansas
Wichita State University, Wichita, Kansas

SELECTED GROUP EXHIBITIONS

1985 *A Decade of American Realism: 1975-1985*, The Wichita Art Museum, Wichita, Kansas

1984 *About Face*, Art Museum of South Texas, Corpus Christi, Texas, traveled to: Nave Museum, Victoria, Texas and Texas Tech University Art Museum, Lubbock, Texas

1983 *American Still Life 1945-1983*, Contemporary Arts Museum, Houston, Texas; traveled to Albright-Know Art Gallery, Buffalo, New York; Columbus Museum of Art, Columbus, Ohio; Neuberger Mueseum, Purchase, New York; Portland Art Museum, Portland, Oregon
Realism 1983, Southeastern Center for Contemporary Arts Center, New Orleans, Louisiana
Contemporary Allegory Show, Chrysler Museum, Norfolk, Virginia

1982 *The Human Figure in Contemporary Art*, Contemporary Arts Center, New Orleans, Louisiana

1981 *An Invitational Exhibition of Monumental Art by Southern Artists*, Memphis State University, Memphis, Tennessee
The Institute of Contemporary Art of the Virginia Museum, Richmond, Virginia
Colorado Institute of Art, Denver, Colorado

1980 *Visions*, Mid-America Arts Alliance Traveling Exhibition organized by Springfield Art Museum, Springfield, Missouri
Menagerie, Taft Muesum, Cincinnati, Ohio

1979 *Art for the Collector*, Springfield Art Museum, Springfield, Missouri

1977 *Recent Acquisitions*, Hirshhorn Museum and Sculpture Garden, Smithsonian Institution, Washington, D.C.
A View of a Decade, Museum of Contemporary Art, Chicago, Illinois
Downtown Dog Show, Museum of Fine Arts, San Francisco, California

1975 *Biennial of Contemporary American Art*, Whitney Museum of American Art, New York, New York

1974 *Donald Roller Wilson and Bruce Monical*, Ars Longa Galleries, Houston, Texas